19

Enjoy your new
adventures!
Merry Christmas!
Love,
Mom

IMAGES
of America
GRAND RAPIDS

ON THE COVER: Reporters from WOOD Radio and a group of Grand Rapids Fire Department firefighters pose with their new Ahrens Fox fire engine at the LaGrave Avenue Fire Station in 1931. (Grand Rapids Public Museum.)

IMAGES
of America

GRAND RAPIDS

Alex Forist and Tim Gleisner

ARCADIA
PUBLISHING

Published by Arcadia Publishing
Charleston, South Carolina

Library of Congress Control Number: 2015938222

For all general information, please contact Arcadia Publishing:
Telephone 843-853-2070
Fax 843-853-0044
E-mail sales@arcadiapublishing.com
For customer service and orders:
Toll-Free 1-888-313-2665

Visit us on the Internet at www.arcadiapublishing.com

CONTENTS

ACKNOWLEDGMENTS

We would like to gratefully acknowledge the support of the staff at both the Grand Rapids Public Museum and the Grand Rapids Public Library. Tom Dilley deserves the credit for putting us up to this, and both he and Diana Barrett offered a wealth of helpful suggestions on the text. Our editors at Arcadia, Jacel Egan, and especially Maggie Bullwinkel, offered constant support and encouragement and somehow managed to remain polite even after many missed deadlines. Finally, we could not have done this without our families, so thank you, Sara and Sophia and Anjie and Nate.

INTRODUCTION

The history of any community is a continuous struggle between continuity and change, and Grand Rapids is no exception. Our city is fortunate that many of the physical manifestations of our past have survived in the collections of the Grand Rapids Public Museum and Grand Rapids Public Library. These archives, created from donations by city residents and amassed over more than a century-and-a-half of collecting, give us the opportunity to actually see our past, albeit as through a glass, darkly.

When we stop to look at the visual record of Grand Rapids' past from the vantage point of 2015, it is tempting to see our history as a simple story of progress. From the Norton Mounds to *La Grande Vitesse*, it is indisputable that much has changed in Grand Rapids over the centuries. But those changes were not forgone conclusions for the people who lived them. Every choice, from how to lay out the streets of the new village in the 1830s, to the decision to participate in federally funded urban renewal in the 1960s, was made by people and was fraught with conflict. If any one of these choices had been made another way, Grand Rapids might look much different than it does today.

With that in mind, we have attempted to choose images that demonstrate both the longevity and persistence of certain aspects of Grand Rapids history, as well as document the many changes that have taken place over the years. In order to create a volume that would be enjoyable to peruse, easy to reference, and visually cohesive, we have chosen to structure the book into the following four chapters: The River, Industry, Neighborhoods, and Community Institutions. Although these designations are not mutually exclusive—for example churches, which we have chosen to place in the Neighborhoods chapter, could just as easily have been included under the heading of Community Institutions—we feel that they allow us to demonstrate both the great breadth and depth of the collections at both the museum and the library, while still offering something resembling a narrative history of Grand Rapids from the time of its earliest settlement to approximately 1970.

The book, like Grand Rapids, starts with the river. Called "Owashtanong" or the "Far Flowing Waters" by the Native Americans, the Grand River rises in Jackson County and flows westward across the state, passing directly through the center of downtown Grand Rapids on its journey to Grand Haven and Lake Michigan. The images in this chapter document the river and include some of the earliest depictions of Grand Rapids known to exist, even predating the invention of photography. With these maps, sketches, and paintings as our point of departure, we set sail down the river of time to observe how multiple generations of Grand Rapidians have interacted with the central geographical feature of their community.

The choice to settle at the rapids of the Grand River proved fortuitous for the development of industry. From the very beginning, residents of Grand Rapids capitalized on the rich natural resources of the Grand River Valley, not only to build up their own community, but to create a wealth of goods that they could export to the entire world. The second chapter offers a roughly

chronological overview of the many industries and commercial services Grand Rapids generated in the 19th and 20th centuries. From obscure and long-vanished industries like the production of quicklime, through the booming years as the "Furniture City," and into the modern era of international corporations, these images bear witness to Grand Rapids as a city of industry.

The process of place-making has been repeated all over Grand Rapids with the development of unique neighborhoods, each with their own persistence and character. Over the years, many different groups of people have made their homes in Grand Rapids and have defined the shifting boundaries of their neighborhoods based on the exigencies of the times. At the most basic geographical level, the Grand River bisects the city into eastern and western portions, and while entirely artificial, the street numbering system has created a city of four quadrants. However, these divisions are only a beginning, as immigrant groups, religious congregations, and social classes have created a network of neighborhoods, sometimes overlapping, sometimes strictly segregated, which together make up the patchwork of the city. The images in this chapter depict the schools, parks, churches, and businesses that make up neighborhoods all around Grand Rapids, spiraling outwards from downtown, through Heritage Hill, Grandville Avenue, and Eastown, to the west side of the Grand River and the suburban edges of the city limits.

The final chapter contains images of the community institutions that the people of Grand Rapids have built over the almost two centuries of our history. The Grand Rapids Public Museum and Grand Rapids Public Library, from whose collections all of the photographs in this book were taken, are just two of the many venerable institutions represented here. From amusement to education, from government buildings to stately hotels, to a few of the more recent additions such as public art. These institutions are what have made Grand Rapids a place that people want to live. Many of them have persisted into the present day; revealing a snapshot of their origins and histories is always illuminating.

Anyone with an interest in the history of Grand Rapids benefits from the work of the many talented authors who have chronicled our past, and we are no exception. Without the work of Baxter, Goss, Lydens, Olson, Dilley, and many others, this book would not exist. Our own small contribution to this illustrious company, the thing that we hope will make this book appealing, and the reason for undertaking this project, is the reach and accessibility of Arcadia's publications. At our regular day jobs, we both work hard to preserve the photographs, documents, and artifacts that make up our shared history. But simply preserving these historical resources is not enough. Finding new ways to reach out and make the material more accessible to the people in our community are the real goals, and publications like this are just one more way to do that.

One final note—the text and images included here are not meant to be exhaustive, nor, we realize, are they fully representative. By acknowledging that we all work within the frameworks and restrictions of our own biases, and the realities of the restraints on both time and other resources, we present only one interpretation of Grand Rapids history. So whether this is a starting point for your journey, or one of many volumes on your shelf, we thank you for reading and appreciate your company as we stroll back through time to examine Images of America: *Grand Rapids*.

One

THE RIVER

The Grand River has always been the center of this community. From the very beginning, the river has exerted a kind of pull on the people of the region, drawing them, like tributaries, to it. The Hopewell people who lived here 2,000 years ago knew the gravity of the river and buried their dead in sacred earthen mounds on its banks. Later, the Anishinabe, Native American peoples of the region, followed the course of the river as they traveled the forests of Michigan. For French fur traders, the river was their connection to the markets of Europe. And finally, when Yankee settlers and immigrants from the Netherlands, Germany, Poland, Lithuania, and the rest of the world came to the Grand River valley, they, too, decided it was a good place to live.

This chapter will look at images of the Grand River, from the very earliest maps, sketches, and paintings, to some of the area's earliest photographs. It will attempt to show how Grand Rapids and the river that it is named after evolved together. One of the first questions that a newcomer to Grand Rapids often asks is, "Where are the rapids?" The answer is both simple and complex. Simply, they are gone, removed with great labor by the first generation of Grand Rapidians in an ultimately failed attempt to create a navigable waterway. However, the full story of the interaction of the people and the river is much more complicated. At first glance, it may seem that people have changed the river; dams have been built, canals have been dug, and tragic amounts of pollution have been dumped. But now, as Grand Rapids approaches its bicentennial, many of these historical processes are coming full circle. The pollution is being cleaned up, the canals are long covered over, and the dams may soon be removed to restore the long-lost rapids, and still, the river flows on.

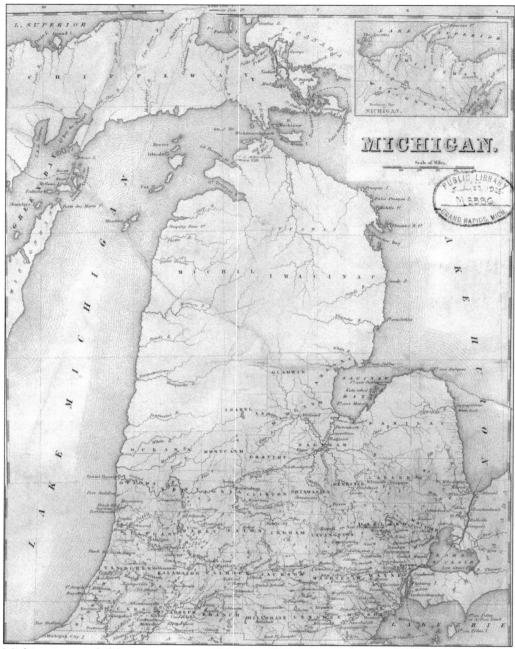

Michigan was settled from east to west and from south to north. Early maps, like this 1838 example, show only a roughly accurate depiction of the state's geography with significantly more detail in the populated southeastern portion of the state. At this early date, Grand Rapids was referred to as the village of Kent. (Grand Rapids Public Library.)

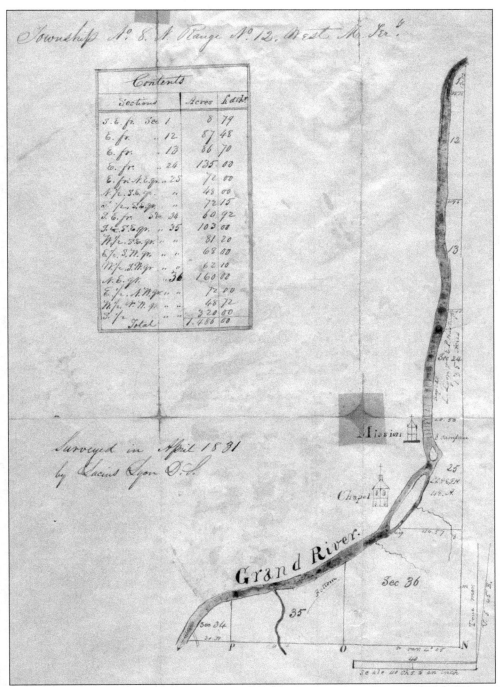

This rough survey, created by Lucius Lyon in 1831, gives a basic idea of how the land that would become Grand Rapids looked when settlers first arrived. Note the islands in the Grand River where downtown Grand Rapids now stands. Documents like this were important to the growing community because they established clear and mutually agreed upon property lines. (Grand Rapids Public Library.)

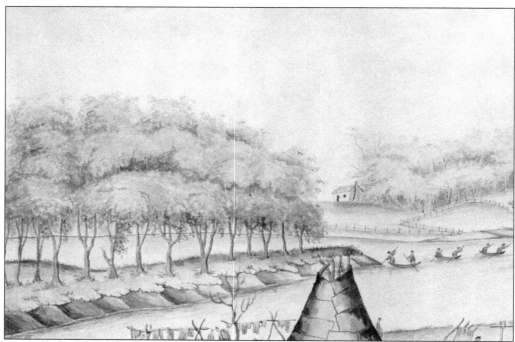

The Reverend John Booth sketched this image of the gathering place at the rapids of the Grand River in 1831. By that time, Native Americans had been coming to this place for centuries to gather and trade. By comparison, the Reverend Isaac McCoy's Baptist mission was established in 1823, and Louis Campau's fur-trading cabin was built three years later in 1826. (Grand Rapids Public Library.)

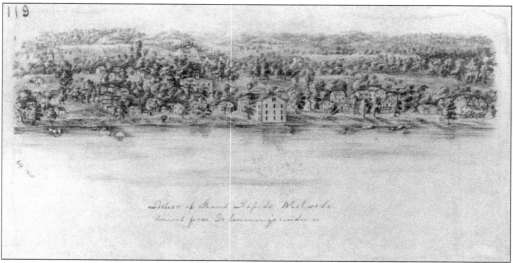

In 1860, Mary Cummings drew a similar scene, also looking west across the Grand River, from her home on Crescent Street. In just 30 years, the tiny settlement had grown into a thriving town. (Grand Rapids Public Library.)

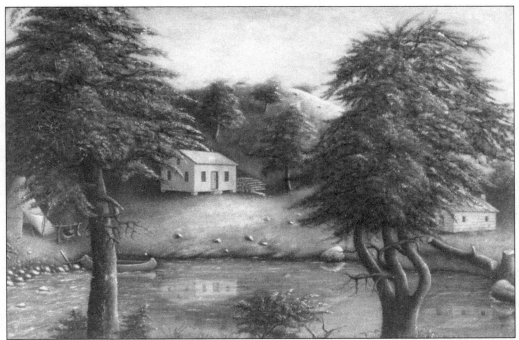

Aaron Turner's painting of Grand Rapids is a combination of history and whimsy. Painted in 1890, the colorfully oiled landscape depicts Turner's recollection of what Grand Rapids looked like when he arrived as a 13-year-old boy in 1836. It includes a Native American dwelling, Joel Guild's house, and Louis Campau's fur storage shed, all peacefully situated on the banks of the Grand River where downtown Grand Rapids now stands. (Grand Rapids Public Museum.)

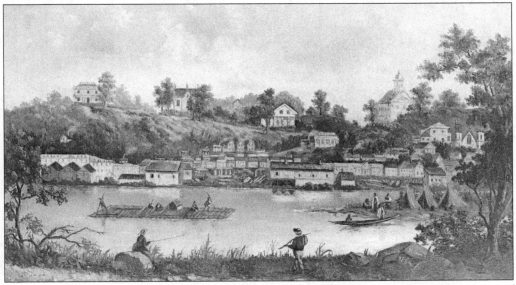

The Grand River is also a central feature of 16-year-old Sarah Nelson's idyllic 1856 painting of Grand Rapids. Taken together, these four images provide almost the entirety of the graphic record of the community before the invention of photography brought a whole new way to document history. (Grand Rapids Public Library.)

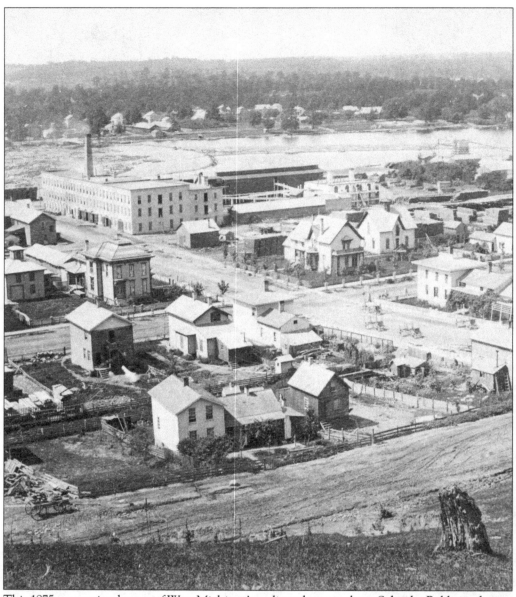

This 1875 stereo view by one of West Michigan's earliest photographers, Schuyler Baldwin, depicts the wing dam in the Grand River just upstream of downtown, near Sixth Street. The dam was completed in 1849, visible here as an arc in the river in the background, and was used to divert water into power canals on both sides of the river. (Grand Rapids Public Museum.)

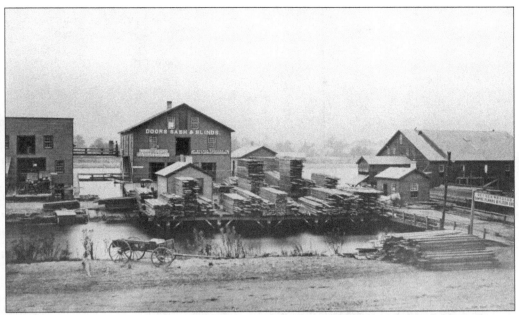

The Reuben Wheeler and Company factory was located on the east bank of the Grand River between the river and the canal when this photograph was taken in 1870. In addition to operating this sash and blind mill, Wheeler was a successful architect who designed many early homes and buildings in Grand Rapids. (Grand Rapids Public Museum.)

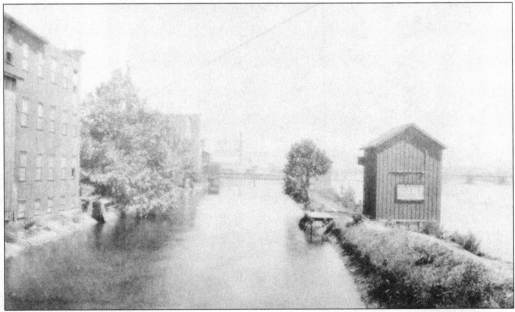

Following the growth of the city, the west side canal was completed in 1867. This photograph from about 1900 shows a view looking north, or upstream, along the canal from near Fulton Street where the Grand Rapids Public Museum and the Gerald R. Ford Museum are now located. The factories along the canal used waterpower to generate electricity and operate machinery. (Grand Rapids Public Museum.)

15

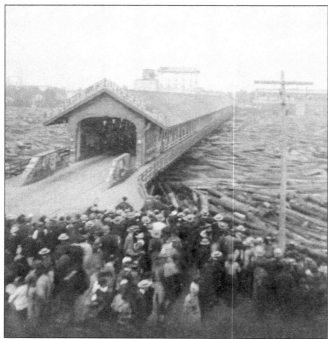

Flooding was a common event along the Grand River. Sometimes caused by logjams, sometimes by ice, or simply too much rain, the river frequently overflowed its banks. This image shows the east end of the Pearl Street Bridge on July 26, 1883, with the river jammed with logs. (Grand Rapids Public Museum.)

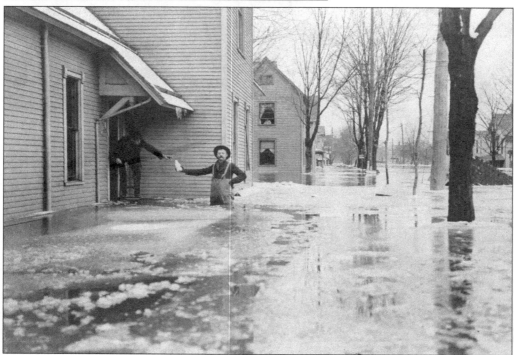

In March 1904, an ice jam on the Grand River combined with heavy rains to produce the worst flooding in Grand Rapids history. The river rose to 19.5 feet, and without any flood walls or other abatement systems, much of the lower West Side was covered in water, and 2,500 homes and businesses were flooded. (Grand Rapids Public Museum.)

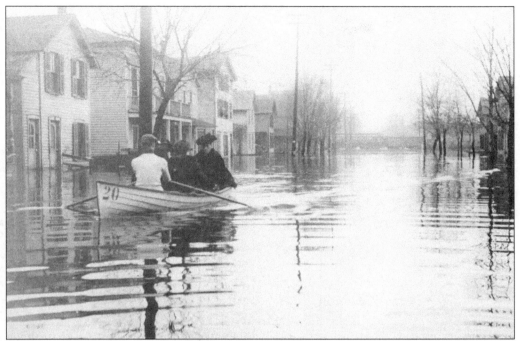

This photograph from the 1904 flood shows a chivalrous gentleman rowing a pair of ladies to safety down a flooded west side street. The 1904 flood was finally surpassed in scope in 2013, when the Grand River rose to 22 feet and caused millions of dollars in damages. (Grand Rapids Public Museum.)

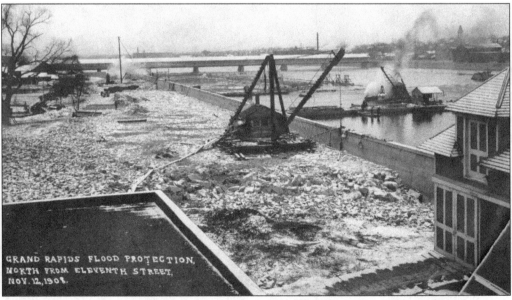

GRAND RAPIDS FLOOD PROTECTION.
NORTH FROM ELEVENTH STREET.
NOV. 12, 1908.

This 1908 image shows the construction of flood walls along the banks of the Grand River north of downtown. After the disaster of 1904, the flood walls were seen as a necessity. For the rest of the 20th century, these flood walls prevented catastrophic flooding in Grand Rapids. (Grand Rapids Public Museum.)

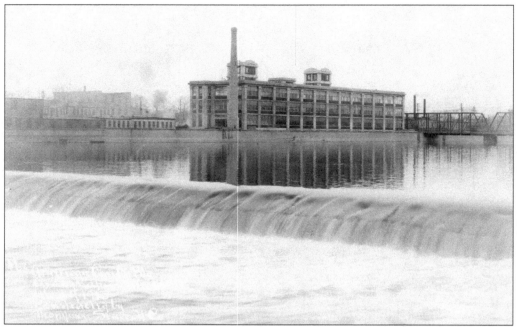

The Fourth Street dam, shown here in the 1920s, is the largest of the five low-head dams spanning the Grand River. This series of dams was constructed during the 1920s to create an aesthetically pleasing, smooth, and terraced look to the river. The building in the background is the American Can Company Factory on the west side of the river. (Grand Rapids Public Museum.)

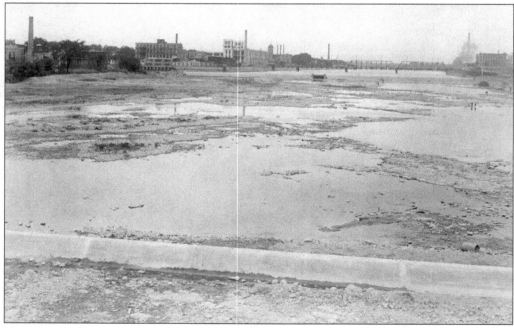

Here is something most Grand Rapidians have never seen—the Grand River with no water! This 1928 photograph was taken looking north during the construction of the present-day dams. (Grand Rapids Public Library.)

This 1930 photograph at Fulton Street shows a section of a cofferdam that was being constructed in order to lay a pipe. The men are John J. Rens (city inspector), Clayton Meyers, Jack VanderBrink, Henry Sikkema, and Ralph Williams. On top of the high bank in the background are billboards for Litscher Electric Company and Security Storage and Transfer Company. (Grand Rapids Public Library.)

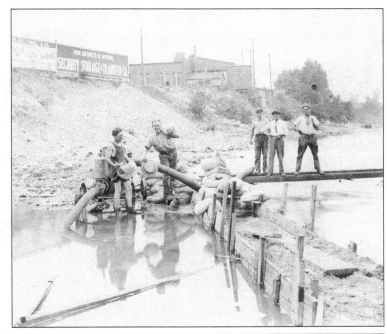

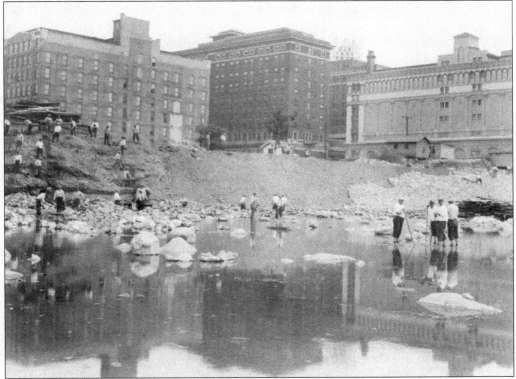

This photograph, taken on August 31, 1931, shows workmen reinforcing the riverbank to secure the foundation for the new civic auditorium. The auditorium was completed in 1933, and its facade still stands at the foot of Lyon Street. (Grand Rapids Public Library.)

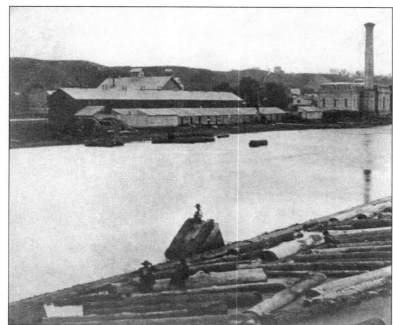

This early view from Leonard Street Bridge is from one of the library's earliest collections, the George Fitch Photo Collection. Note the log booms on the east bank of the Grand River. The Coldbrook Water Station is in the background on the right. (Grand Rapids Public Library.)

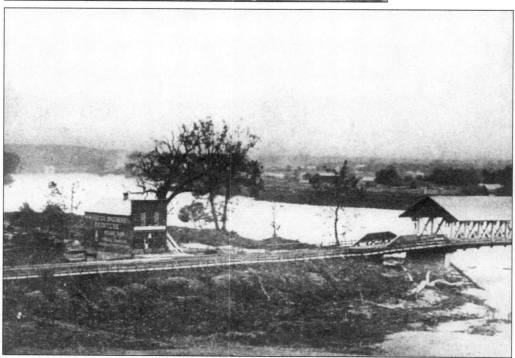

Most people today would be utterly baffled by the idea of paying a toll every time they wanted to cross one of the bridges across the Grand River. But in fact, many of the early privately owned bridges started out this way. This 1865 view shows a wooden covered bridge on Pearl Street at Island No. 1. The Van Houten Brothers painting company is located on the left. (Grand Rapids Public Library.)

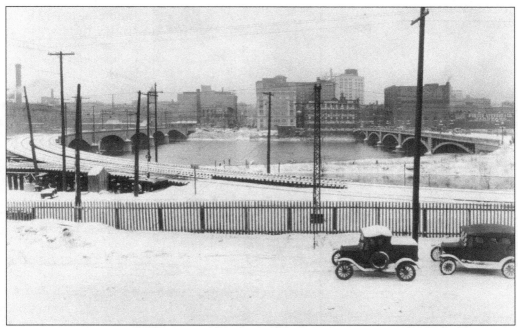

This view, taken from the west bank of the Grand River looking east, shows the pair of bridges at Lyon Street (left) and Pearl Street. In 1926, when this photograph was taken, the Lyon Street Bridge was used as a train bridge by local streetcars and regional interurban railroads. Today, it is known as the Gillett Pedestrian Bridge. (Grand Rapids Public Museum.)

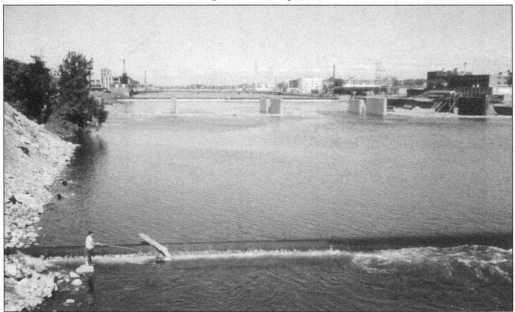

This view looks north along the Grand River in downtown Grand Rapids and was probably taken from the Bridge Street Bridge. Visible in the foreground is a fisherman standing near one of the five low-head dams. Farther upstream are the pilings for the Interstate 196 Bridge, which was being constructed when this photograph was taken in about 1963. (Grand Rapids Public Museum.)

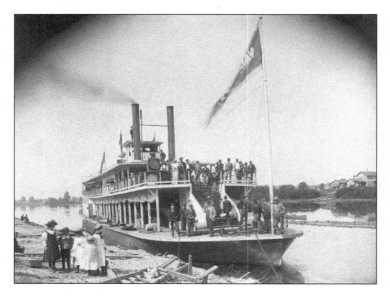

During the mid-19th century, there was a vibrant transportation industry ferrying people and products on the Grand River. However, the river was not navigable through Grand Rapids and was split into upstream and downstream sections. The *Valley City*, shown here at her launch in 1892, was one of the last river steamers to carry passengers between Grand Rapids and Grand Haven. (Grand Rapids Public Museum.)

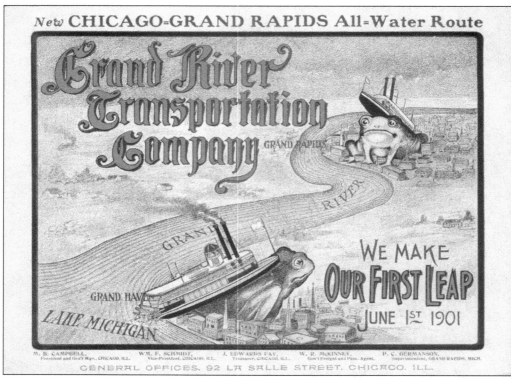

As the 20th century began, travelers in West Michigan had an abundance of transportation options available to them, and river travel was on the way out. This flyer advertised the maiden voyage of the Grand River Transportation Company in June 1901. The company was out of business by August. (Grand Rapids Public Museum.)

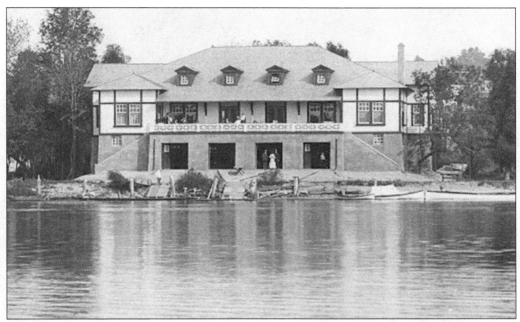

Recreation on the Grand River has taken many forms over the years. This photograph shows the well-appointed Grand Rapids Boat and Canoe Club around 1900. This popular club was located on the eastern bank of the Grand River just north of North Park Bridge. (Grand Rapids Public Library.)

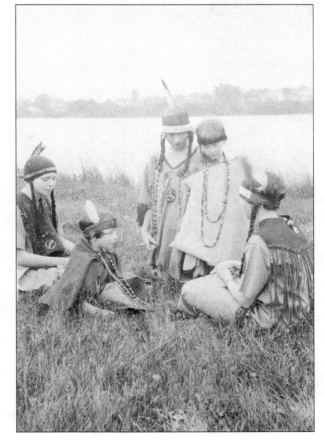

In 1926, Grand Rapids celebrated the centennial of the founding of the city. According to the photographer Murch Morris, this pageant took place by the Grand River near the Ann Street Bridge. The photograph shows five children in Native American dress on the bank of the river. (Grand Rapids Public Library.)

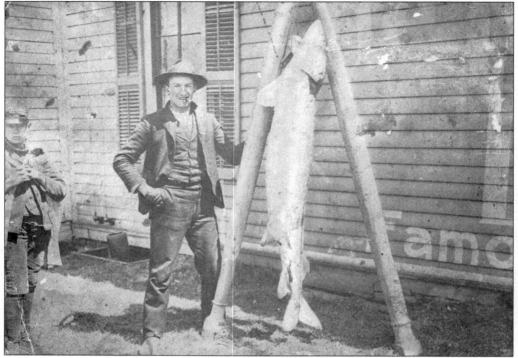

Before pollution became a significant factor later in the 20th century, the Grand River was filled with fish, like this seven-foot sturgeon, which was caught off the Bridge Street Bridge in 1906. (Grand Rapids Public Museum.)

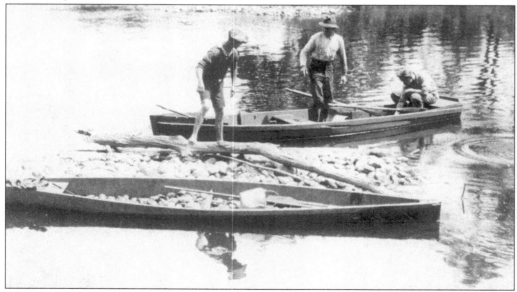

Clamming was another popular pastime on the Grand River. Besides being used as a food source, clam and mussel shells were harvested for mother-of-pearl, which was used to make buttons for clothing and jewelry. This photograph shows three men clam fishing on the Grand River in 1928. (Grand Rapids Public Library.)

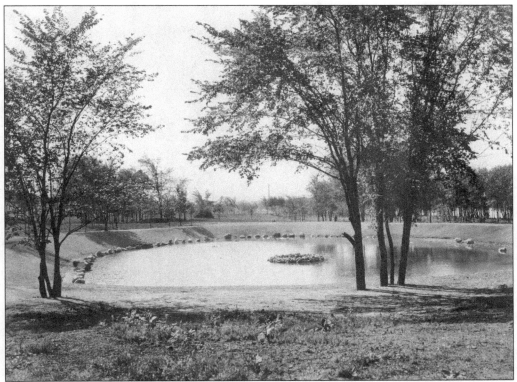

As anyone who has visited Riverside Park in the spring knows, the Grand River still floods regularly. Portions of the park, such as the pool shown here, were landscaped by municipally funded work projects during the Great Depression of the 1930s. (Grand Rapids Public Library.)

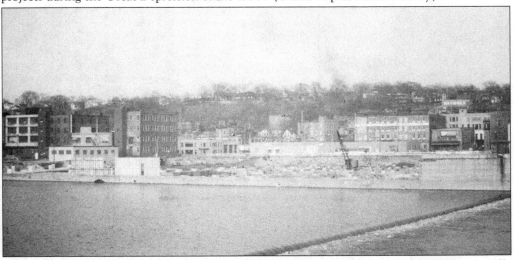

Through the first half of the 20th century, Grand Rapids continued to grow and develop, especially in its downtown area centered on the Grand River. A major turning point came in the early 1960s when Grand Rapidians voted to fund a program of urban renewal, which would result in the demolition of many historic buildings and their replacement with new construction. (Grand Rapids Public Museum.)

By the late 1960s, when this view of the west bank of the Grand River was photographed, many manufacturing and retail businesses in downtown Grand Rapids were suffering. The promised benefits of urban renewal were slow to materialize, and the 1970s and 1980s were a period of decline as most downtown retailers moved to the suburbs, and many manufacturers, like the Voigt Milling Company (far left), closed entirely. (Grand Rapids Public Museum.)

Water quality on the Grand River has steadily improved over the last few decades. The construction of a wastewater treatment plant, as well as Grand Rapids' move away from the combined sewer systems popular in the early 20th century, ensures that sewer runoff does not pollute the Grand River during heavy rains. (Grand Rapids Public Library.)

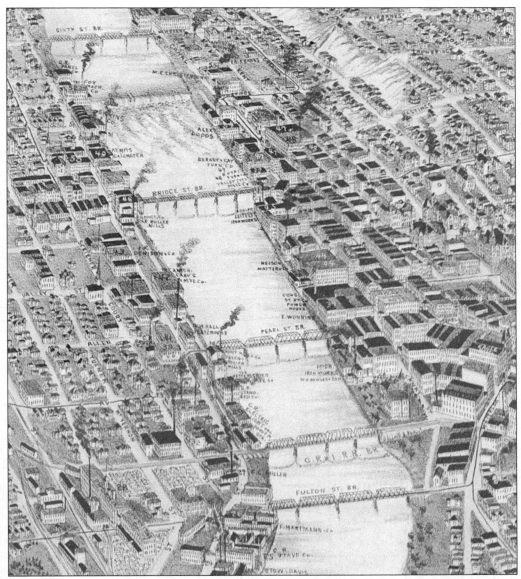

This 1893 map of Grand River, with its bird's-eye view, should look very familiar to a modern observer. The main downtown bridges are almost all in place, with the exception of the interurban or Gillette Bridge just north of Pearl Street. The current "blue" bridge is marked on this map with its original purpose as a railroad bridge for the Grand Rapids & Indiana Railroad. (Grand Rapids Public Museum.)

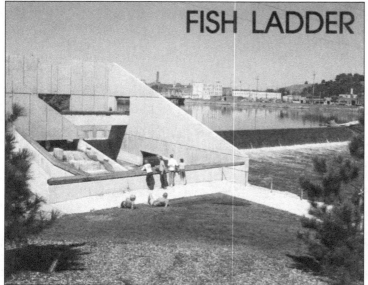

FISH LADDER

Both the citizens of Grand Rapids and the fish in the Grand River were given a gift in 1974 when a functional sculpture by artist Joseph Kinnebrew, titled *Grand River Sculpture*, was unveiled on the river's west bank at the Sixth Street Dam. Better known as the fish ladder, this Grand Rapids destination provides a way for migratory fish to circumvent the dam and for eager visitors to watch the fish climb the ladder. (Grand Rapids Public Library.)

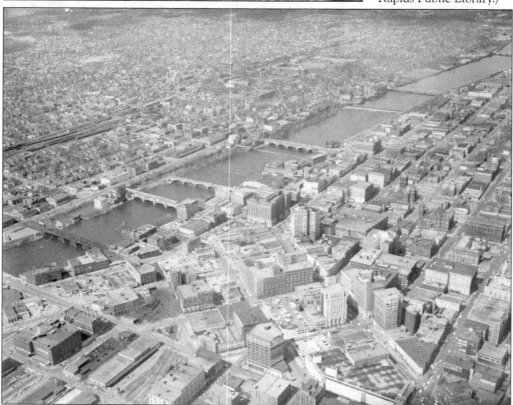

The Grand River has changed significantly in the almost two centuries since Grand Rapids was founded. The rapids and islands have disappeared, dams and canals have come and gone, and bridges and flood walls have been built, but still, the river remains the geographic and spiritual center of this community. (Grand Rapids Public Museum.)

Two

INDUSTRY

Grand Rapids' first industries developed because of opportunities afforded by its natural resources, particularly the Grand River. In its early years, Grand Rapids boasted a diverse set of industries, all helping to support a growing community on the frontier. Early ventures into limestone and salt mining proved profitable but were short lived. The plaster, or gypsum, mines beneath the city's southwest quadrant proved a long-lasting business. Flour mills, like those operated by the Voigt and Valley City Milling Companies, were able to take the bountiful harvests of surrounding farms and turn them into food for the city with enough left over to export. And because all that hard work left Grand Rapidians awfully thirsty, an active beer brewing industry, developed mostly by German immigrants, kept the city supplied with high-quality lager.

Historically, Grand Rapids is known as a one-industry city. The Furniture City was built in the years following the Civil War when a variety of circumstances came together in the right place at the right time. The abundant hardwood forests of Northern Michigan provided the raw materials, the rivers provided the transportation, and Dutch and German immigrants provided the workforce. Together, they supplied a nation with high-quality furniture that was synonymous with the city that produced it.

But is Grand Rapids still the furniture city? If so, it is because of a different kind of furniture made by companies like Steelcase and the American Seating Company. But nowadays, these modern furniture makers from Grand Rapids have to compete for name recognition with other billion-dollar companies such as Meijer, Amway, and Bissell. This chapter explores a sample of Grand Rapids businesses, from the giants of the furniture industry to small family-owned shops, each making its own unique imprint on the city's character.

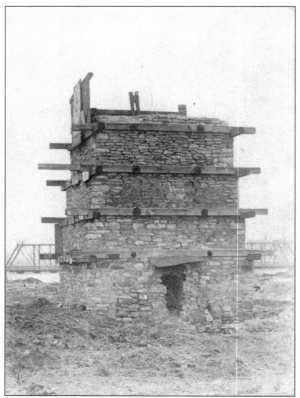

A lime kiln is a structure designed to heat large amounts of crushed limestone to create quicklime, an important building material. Because limestone was readily available in and around the Grand River, the production of quicklime became an important early industry. By 1866, when this photograph was taken, the lime industry of Grand Rapids was producing over 20,000 barrels a year. (Grand Rapids Public Library.)

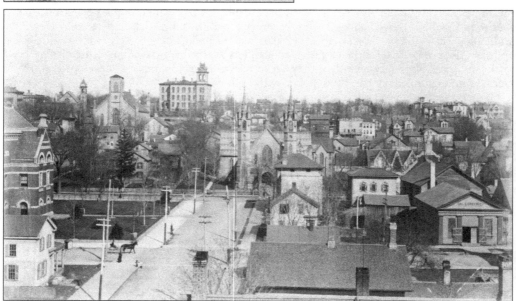

Not all the limestone quarried from the Grand River was crushed and burned. In 1848, hundreds of blocks of limestone were quarried from the river, cut, and hauled up Pearl Street to construct St. Mark's Church, one of the oldest remaining buildings in Grand Rapids, pictured here at center in 1876. (Grand Rapids Public Museum.)

Right away, the settlers at Grand Rapids began to make use of the river for industry. The inscription on these millstones, which are currently located outside the Grand Rapids Public Museum, reads, "First mill stones brought to Grand Rapids and placed in mill on Indian Mill Creek about 1834. Removed by John Ball for a horse block in 1867 and donated by his heirs to the Kent Scientific Museum." (Grand Rapids Public Museum.)

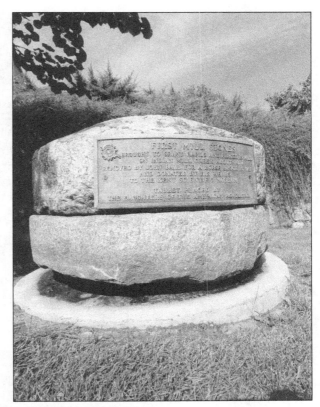

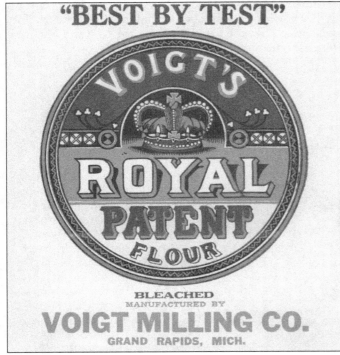

The Voigt Milling Company operated two flour mills on the west bank of the Grand River in downtown Grand Rapids until the 1960s. Its flour was sold all over the eastern United States. This logo was printed on a five-pound flour bag from the 1920s. (Grand Rapids Public Museum.)

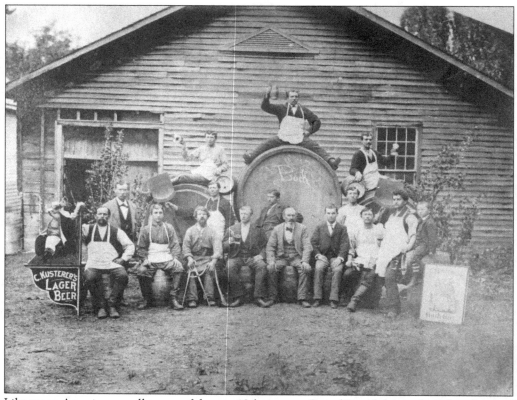

Like many American small towns of the era, 19th-century Grand Rapids boasted an abundance of local breweries. Christoph Kusterer, shown here surrounded by his family and employees in 1876, was a *braumeister* from Germany who established the City Brewery at the corner of Michigan Street and Ionia Avenue in 1849. Cheers! (Grand Rapids Public Library.)

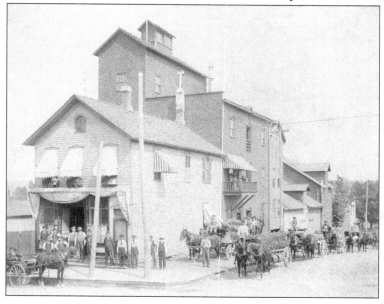

The Tusch Brothers Cincinnati Brewery, pictured here in 1892, was located on Grandville Avenue, just down the street from where Grand Rapids' largest current brewery, the Founders Brewing Company, is now located. (Grand Rapids Public Museum.)

The beer scene in Grand Rapids changed dramatically in 1893 when the Grand Rapids Brewing Company was formed by consolidating six local breweries, including the previously mentioned Kusterers and Tusches. This beer serving tray from about 1905 depicts the company's castle-style brewery, which was built on the site of the old City Brewery at Michigan and Ionia Avenues. (Grand Rapids Public Museum.)

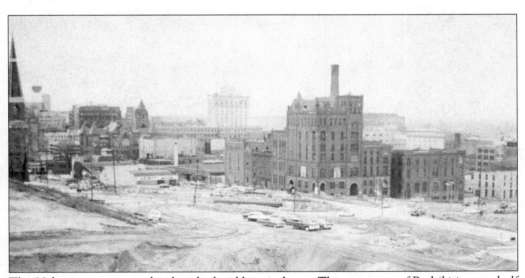

The 20th century was not kind to the local beer industry. Thirteen years of Prohibition put half of American breweries out of business. Before the current microbrewery renaissance, the last local brewer to operate in Grand Rapids was Fox DeLuxe, which closed down in 1951. The brewery was finally demolished during urban renewal in the 1960s, ending more than 100 years of brewing history at that location. (Grand Rapids Public Museum.)

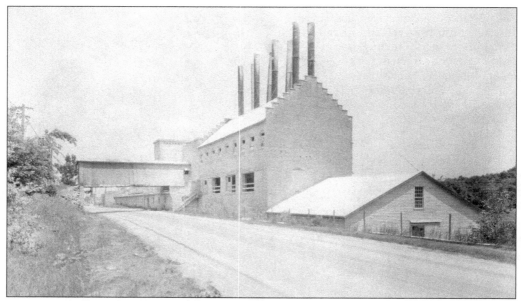

The mining of gypsum or plaster was a profitable industry in Grand Rapids from the earliest days of settlement. The first gypsum mine, begun in 1841, was located at the mouth of the waterway that still bears its name, Plaster Creek. This undated photograph shows the Grand Rapids Plaster Company factory on the city's southwest side. (Grand Rapids Public Museum.)

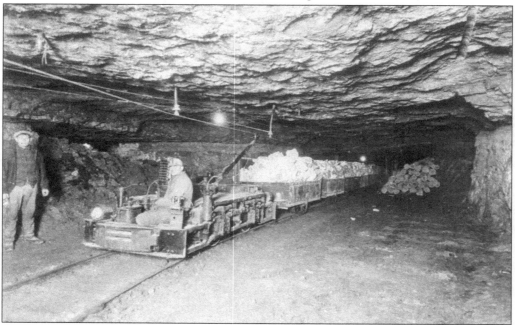

This undated photograph of a cart full of gypsum coming out of the mines may look familiar to a generation of Grand Rapidians who had the opportunity to visit the gypsum mines, often as part of an elementary school field trip! The gypsum mines are still operated today as part of the Michigan Natural Storage Company, which provides underground cold storage to a variety of businesses. (Grand Rapids Public Museum.)

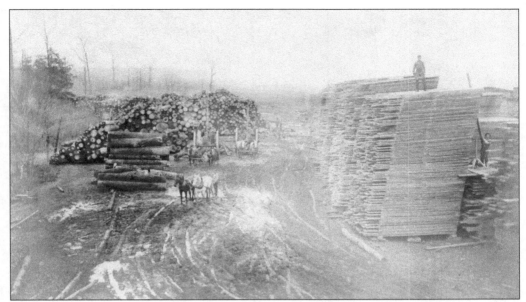

The furniture industry in Grand Rapids grew naturally out of the area's lucrative lumber business. Lumber camps, like the one at Slocum's Grove west of Grand Rapids, were important staging areas where timber was collected before being shipped to the furniture factories. (Grand Rapids Public Museum.)

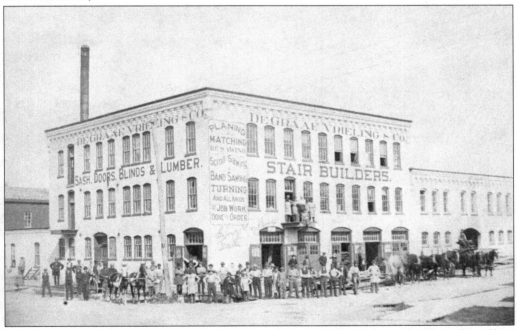

In its early years, the furniture industry in Grand Rapids consisted mostly of simple milling operations like DeGraaf, Vrieling & Co., shown here in 1886. The sign on the building advertises a variety of woodworking services such as planing, sawing, and turning. As early as the 1840s, these proto-furniture factories manufactured the wooden goods needed for the construction of a growing city. (Grand Rapids Public Museum.)

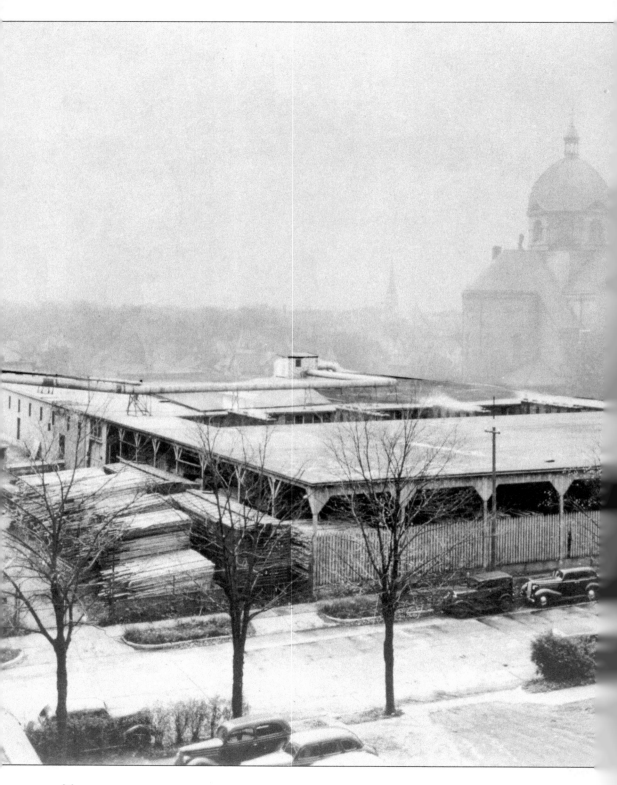

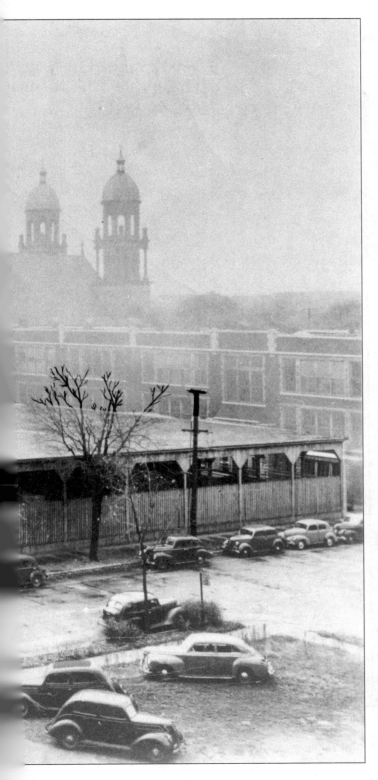

From 1850 to 1950, there were at least 600 different companies in Grand Rapids that manufactured furniture. No wonder Grand Rapids became known as the Furniture City. Although most of the residential furniture companies are long gone, the legacy of the furniture industry persists in Grand Rapids through office furniture manufacturers like Steelcase and fixed seating concerns such as the American Seating Company and the Irwin Seating Company. This hauntingly beautiful image from the 1940s captures the essence of Grand Rapids better than most. The Widdicomb Furniture Factory lumberyard is visible in the foreground, while the spires of St. Adelbert's Basilica dominate the background and skyline. (Grand Rapids Public Library.)

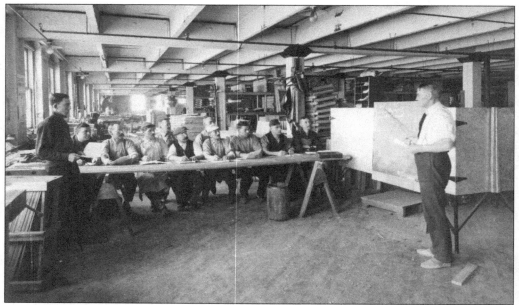

Many furniture factory workers were new immigrants who spoke little or no English. Some companies, like the John D. Raab Chair Company, pictured here, offered English language classes for their employees. (Grand Rapids Public Library.)

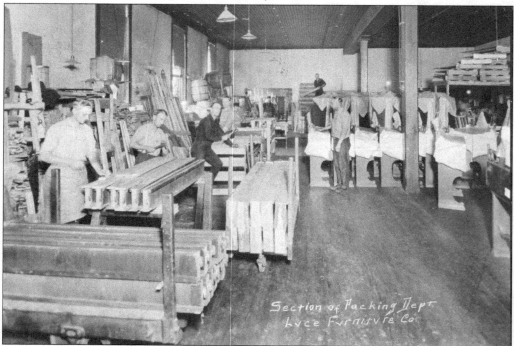

A modern Grand Rapids furniture factory had everything it needed under one roof, including its own packing and shipping department to make sure that a buyer's furniture arrived safe and sound. Shown here is the Luce Furniture Company Packing Department around 1920. (Grand Rapids Public Library.)

The conditions in furniture factories were crowded, dim, and sometimes dangerous. However, workers took pride in the pieces they produced. This c. 1900 image shows workers building tables at the Phoenix Furniture Company. (Grand Rapids Public Library.)

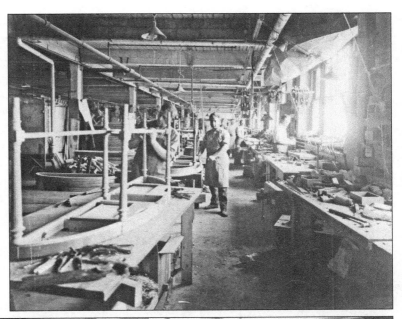

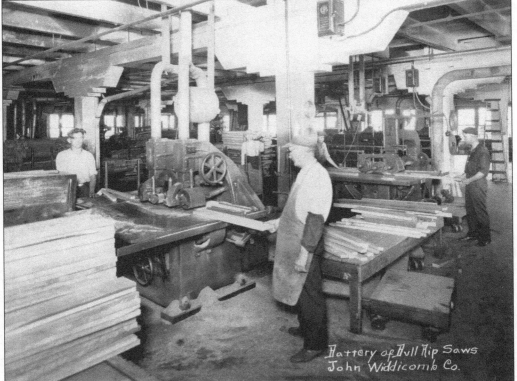

One of the secrets to the success of the Grand Rapids furniture industry was the ability to combine the efficiency offered by modern machinery with an old-fashioned, handcrafted aesthetic. Pictured about 1940, employees of the John Widdicomb Furniture Company use a ripsaw to cut boards. (Grand Rapids Public Library.)

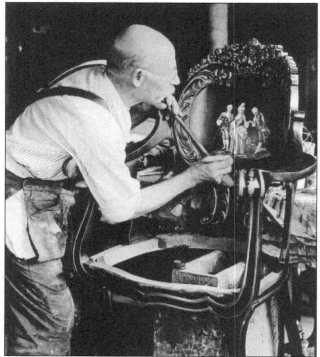

Images from factory interiors reveal the wide variety of people who made the Grand Rapids furniture industry possible. Although Grand Rapids' success rested on the ability to churn out medium-quality furniture in high volumes, the skilled artisans who carved and painted the most high-end pieces remained important. (Grand Rapids Public Museum.)

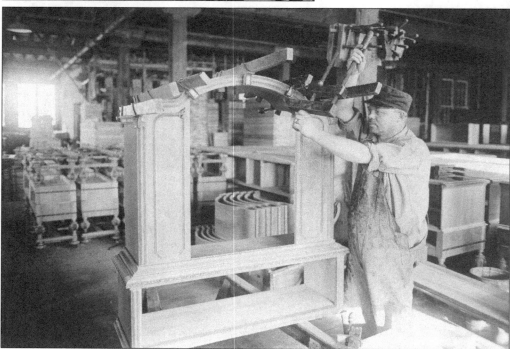

Grand Rapids was not without racial tensions, but the constant need for labor in the furniture factories meant African American workers could sometimes acquire good jobs on the factory floor. (Grand Rapids Public Museum.)

Multiple generations of families often worked together in the furniture factory. Working in the factory meant long hours, dangerous conditions, and hard work, but the relatively high pay and the pride of workmanship made these jobs highly sought after. (Grand Rapids Public Museum.)

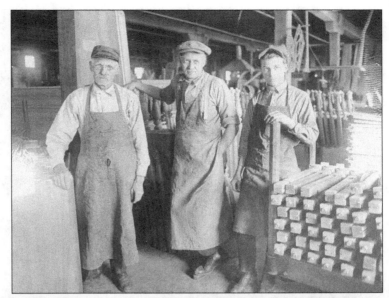

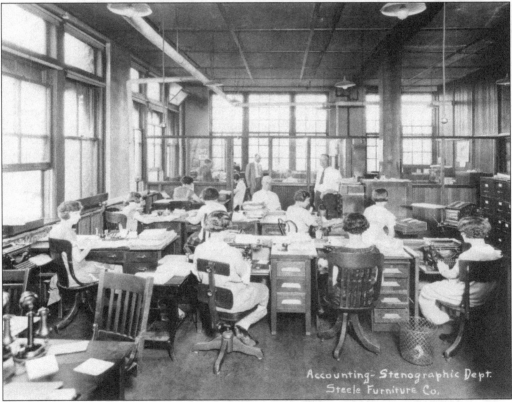

It took more than wood carvers to run a successful furniture factory. These were large-scale businesses that required skilled employees of all types. From about the 1920s onward, many women were able to secure positions in the factories as secretaries or stenographers, like those shown here at the Steele Furniture Company. (Grand Rapids Public Museum.)

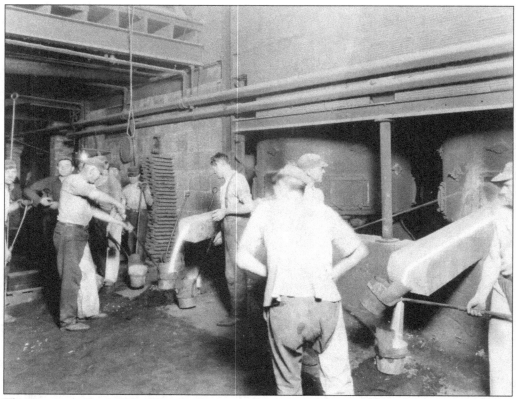

The American Seating Company, still going strong today, is representative of a second generation of furniture manufacturers that expanded beyond creating wooden residential furniture. Instead, American Seating manufactured school desks, stadium and theater seats, and folding chairs, many on large government contracts. This c. 1940 image shows the American Seating Company foundry. (Grand Rapids Public Museum.)

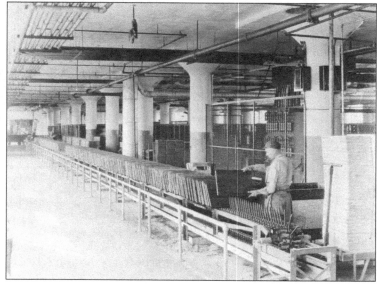

This image conveys some of the scale at which the American Seating Company produced contract furniture; in this case, school desks. (Grand Rapids Public Library.)

OFFICE GRAPHIC A pictorial of office ideas

One of the most famous and enduring companies to arise as part of this second generation of furniture manufacturers in Grand Rapids was the Metal Office Furniture Company. Founded in 1912, the company got its start manufacturing fireproof metal wastebaskets. In 1954, it changed its name to reflect its most popular product line, Steelcase. (Grand Rapids Public Museum.)

Steelcase has produced millions of durable and functional pieces of office furniture in more than a century of business. One of the company's most beautiful pieces of furniture is this secretarial desk and chair designed by Frank Lloyd Wright for the Johnson Wax Company's headquarters in Wisconsin. Legend has it that Wright designed the chairs with only three legs to force workers to sit up straight . . . or risk falling over backwards. (Grand Rapids Public Museum.)

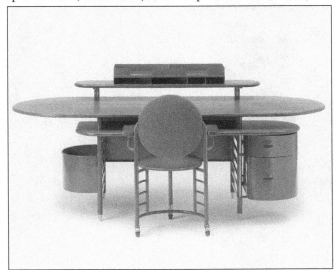

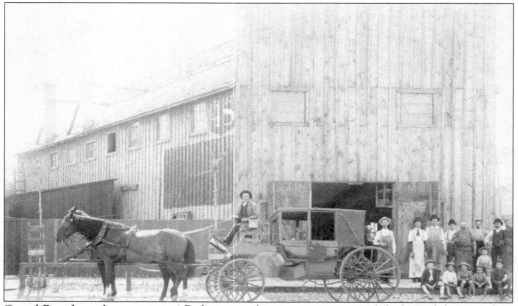

Grand Rapids as the motor city? Perhaps not, but numerous automobile firms did set up shop here before the east side of the state established its dominance in the automotive industry. Pictured here is the Russell & Simmons Carriage Shop on Market Street in 1887. (Grand Rapids Public Museum.)

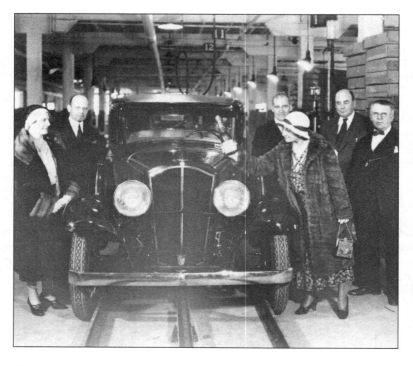

The first DeVaux automobile rolls off the assembly line in Grand Rapids in 1931. DeVauxs were only produced for a couple of years before the Great Depression put the company out of business. A fully restored DeVaux coupe is on permanent display at the Grand Rapids Public Museum. (Grand Rapids Public Museum.)

For the first half of the 20th century, Grand Rapids was a two-newspaper town. Located right next door to each other on East Fulton Street, the *Grand Rapids Press* and *Grand Rapids Herald* each put out a daily paper. The more liberal *Press* released its paper in the evening, while the conservative *Herald* was a morning paper. (Grand Rapids Public Library.)

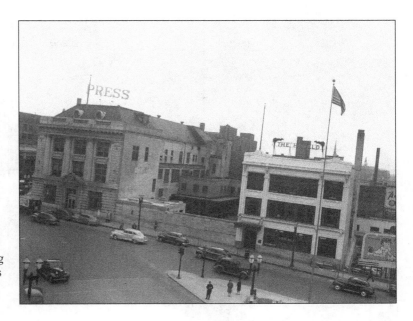

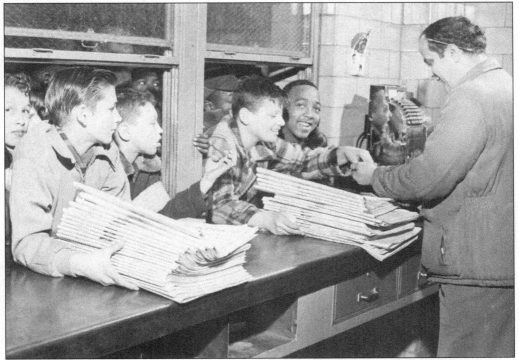

This image shows a group of newsboys reaching for the new editions of the *Grand Rapids Press* in the 1950s. The *Press* had one of the earliest and most successful programs for newsboys in the United States. As a *Grand Rapids Press* newsboy, young boys had the opportunity to play in the newsboy band, go on trips, and visit amusement parks. (Grand Rapids Press Collection at the Grand Rapids Public Museum.)

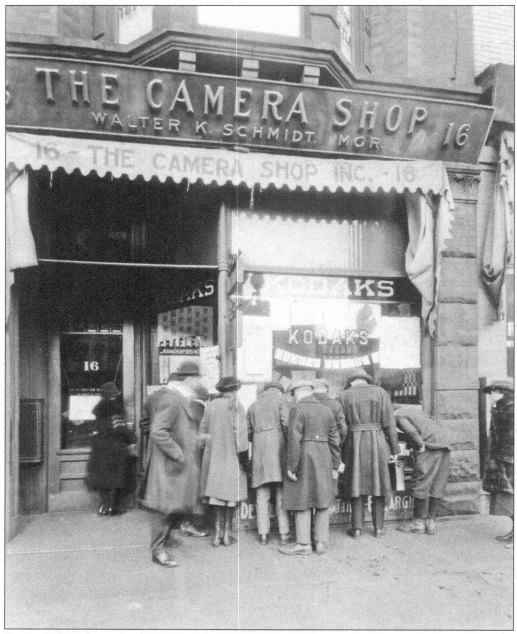

Customers check out the newest model cameras in the windows at the Camera Shop in downtown Grand Rapids. A significant portion of the Grand Rapids Public Museum's collection of 30,000 historic photographs came from the Camera Shop Collection, which was donated to the museum in the 1960s. (Grand Rapids Public Museum.)

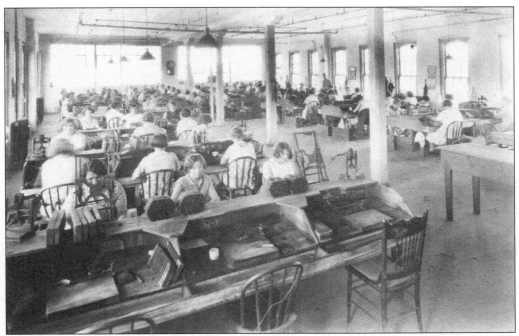

Industry in Grand Rapids was not completely dominated by men. This photograph provides a rare glimpse of women in the workplace; in this case, rolling cigars. (Grand Rapids Public Museum.)

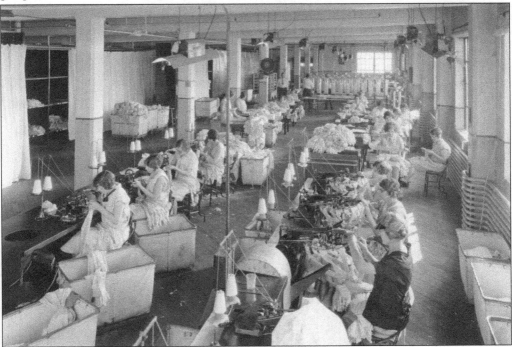

Textile factories, such as the Globe Knitting Works, were also known to employ female workers, although it was almost always in low-level positions where they were seldom paid as much as their male counterparts. (Grand Rapids Public Library.)

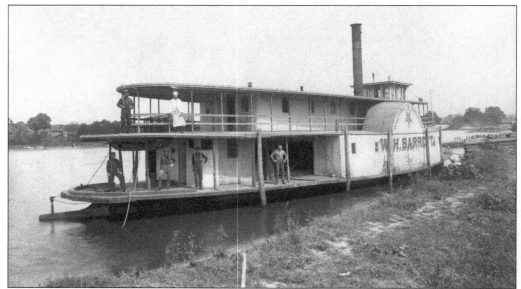

Because of its location on a major waterway just a few miles upstream of Lake Michigan, Grand Rapids had a decided advantage when it came time to ship its manufactured goods to the large established markets around the Great Lakes region. This image shows the steamship *Wm. H. Barrett*, built in 1873, which regularly traveled the Grand River between Grand Rapids and Grand Haven. (Grand Rapids Public Museum.)

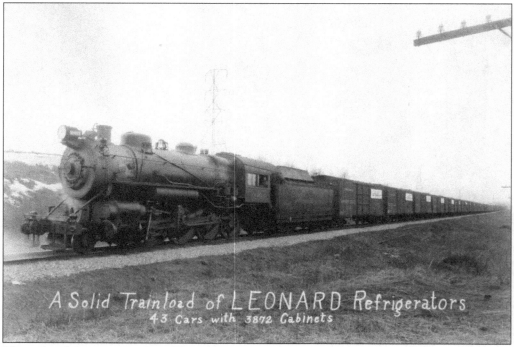

The railroad first came to Grand Rapids in 1857, and dominated shipping and transportation for the next 100 years. Significant early rail lines through Grand Rapids included the Grand Rapids & Indiana Railroad and the Pere Marquette. (Grand Rapids Public Museum.)

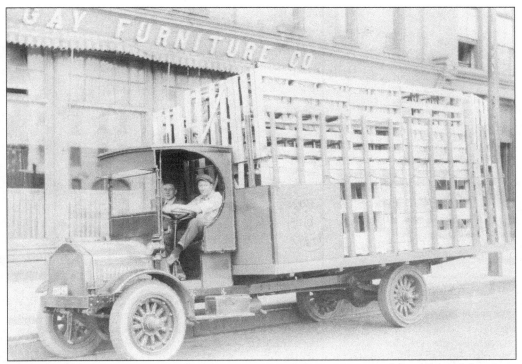

The Berkey and Gay Furniture Company was one of the most successful residential furniture companies in Grand Rapids and in the entire country. By the 1920s, Berkey and Gay employed a fleet of trucks like this one to transport both raw materials and finished goods around town. (Grand Rapids Public Museum.)

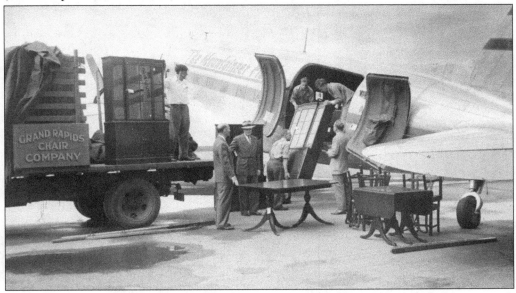

Grand Rapids furniture was so much in demand that it was even shipped by air, which was a much faster, but significantly more expensive, method. This image shows a load of furniture made by the Grand Rapids Chair Company being placed on an airplane. (Grand Rapids Public Library.)

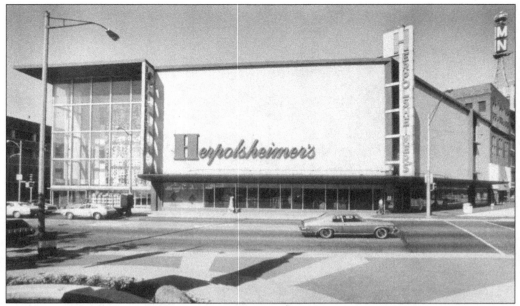

Grand Rapids boasted several homegrown department stores, often founded in the 19th century, which served as anchors for a popular downtown shopping district. Herpolsheimer's Department Store had several locations during its long tenure (1870–1987) in Grand Rapids. This image shows Herpolsheimer's last downtown location, at the northwest corner of Fulton Street and Division Avenue in about 1980. (Grand Rapids Press Collection at the Grand Rapids Public Museum.)

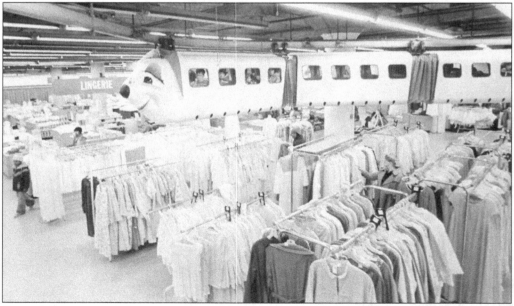

One of the most popular attractions at Herps was the children's passenger train, which ran around the ceiling of the store's lower level. Many Grand Rapidians have fond memories of riding the train, perhaps as Santa's Rocket Express when it was first installed in the 1950s, or as the Caterpillar Express, shown here around 1980. (Grand Rapids Press Collection at the Grand Rapids Public Museum.)

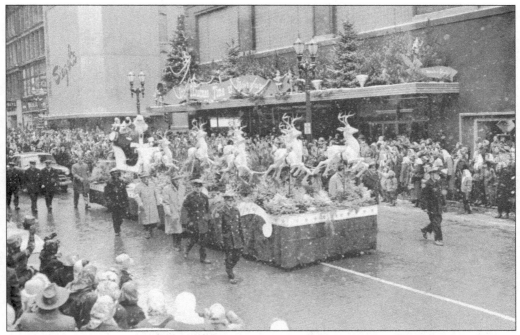

If Herps was known for its train, then Wurzburg's, established in 1872, was known as the place to see Santa Claus. For many years, Wurzburg's sponsored the downtown Santa Claus Parade, shown here proceeding along Monroe Avenue in front of the store. (Grand Rapids Public Library.)

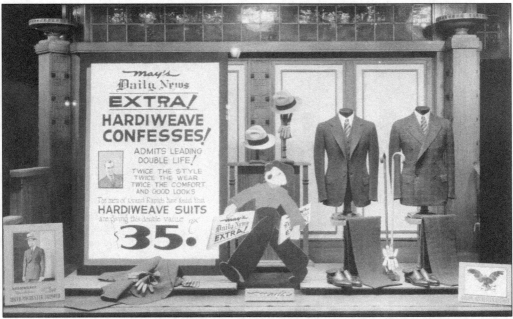

May's was another Grand Rapids Department Store, perhaps best known for its men's clothing. It was the first store in the world to display clothing on hangers rather than folded on shelves. Renowned architect Frank Lloyd Wright designed window displays for May's, as well as the home of owner Meyer May on Madison Avenue in 1909. (Grand Rapids Public Museum.)

The Bissell Carpet Sweeper Company factory is shown here on the east bank of the Grand River, approximately where the DeVos Convention Center now sits. The company was founded in 1876 when Melville Bissell invented a new device, the carpet sweeper, to remove sawdust and other debris from the floor of his crockery shop on Monroe Avenue. By the mid-20th century, when this photograph was taken, Bissell was a household name in Grand Rapids and around the world. (Grand Rapids Public Library.)

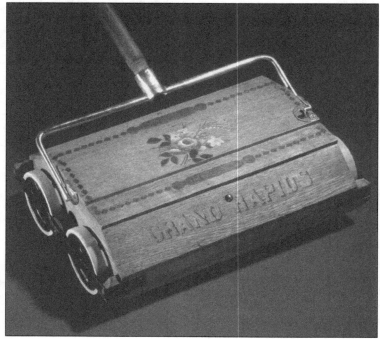

A carpet sweeper performs many of the same duties as a vacuum cleaner but without the need for electricity or the loud noise. The design of many Bissell models had a distinctly feminine touch, which is no surprise considering Melville Bissell's wife stepped in to lead the company after his death in 1889. Anna Bissell became the first female chief executive officer of a major American company. (Grand Rapids Public Museum.)

Seen in the 1950s is a Meijer Thrifty Acres. Having started out of a barber shop in Greenville, Michigan, Meijer has now grown into a chain of grocery stores stretching from Kentucky to Wisconsin. (Grand Rapids Public Library.)

This aerial photograph from the early 1960s shows the humble beginnings of a little company in Ada that made soap. In the decades since, company founders Jay Van Andel and Rich DeVos, both of Grand Rapids, built the Amway Corporation into a worldwide, multibillion-dollar enterprise. (Grand Rapids Press Collection at the Grand Rapids Public Museum.)

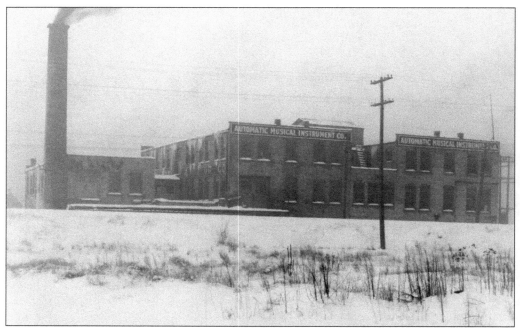

By 1925, AMI, founded in 1909 as the National Automatic Musical Instrument Company, had begun making a significant share of the nation's jukeboxes at its factory in Grand Rapids. The company merged with Rowe in the 1960s, and Rowe International is still making jukeboxes today, although they are no longer manufactured in Grand Rapids. (Grand Rapids Public Museum.)

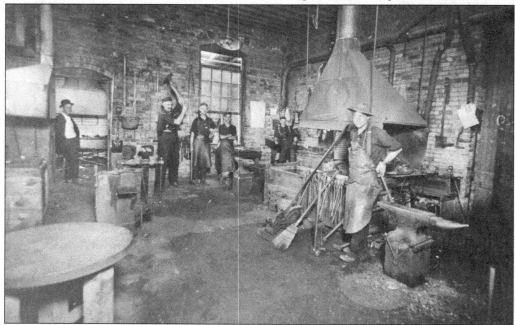

Although Detroit eventually became the Motor City, Grand Rapids has a long history of auto parts manufacturing. One of the significant early companies in this field was Karsten Knudsen's Couple Gear Company, pictured here in the early 20th century. (Grand Rapids Public Library.)

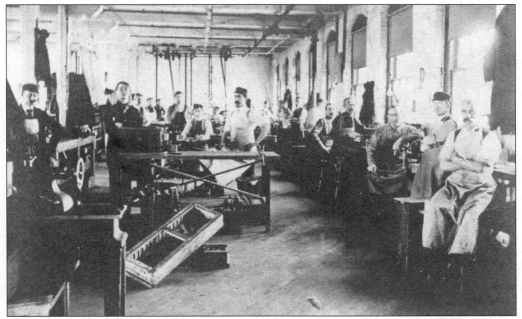

The Fox Typewriter Company was a large manufacturer of manual typewriters in the early 20th century. In 1917, Fox lost a patent infringement case brought by typewriter giant Corona, and was out of business a few years later in 1921. (Grand Rapids Public Library.)

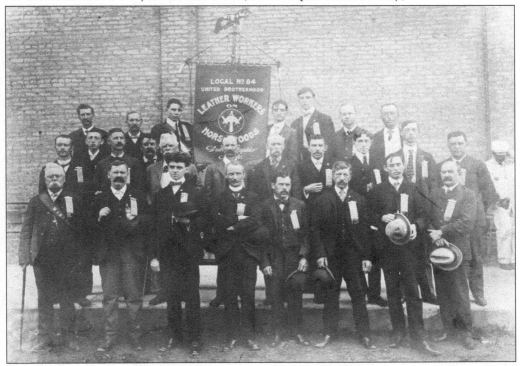

Many workers in Grand Rapids joined professional unions, like the Harness Makers Union shown here posing before the city's annual Labor Day parade in 1912. (Grand Rapids Public Museum.)

Grand Rapids was, and still remains, a city of industry. From its signature furniture factories to the lesser known automotive parts manufacturers to countless others, Grand Rapids made just about everything a person might need, from the cradle to the grave. (Left, Grand Rapids Public Museum; below, Grand Rapids Public Library.)

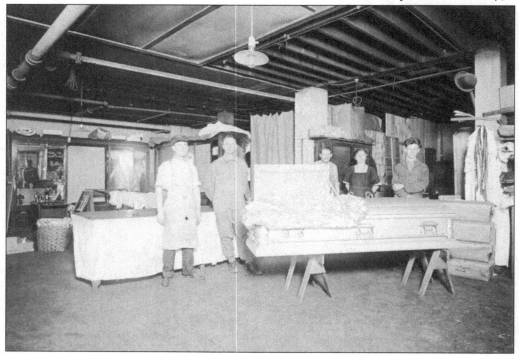

Three

NEIGHBORHOODS

As Grand Rapids' industries grew and prospered, so, too, did its neighborhoods. From the dense skyscrapers of downtown, to the stately avenues of Heritage Hill, to the bustling business districts of the city's four quadrants, each neighborhood developed its own unique identity. However, each neighborhood also contained just about everything one needed for everyday life, and for many of their inhabitants, they became worlds unto themselves. Not very long ago, many Grand Rapidians worked, shopped, played, and worshipped, all within walking distance of their homes. This pattern was repeated on Leonard Street on the northwest side, Plainfield on the northeast side, Hall Street on the southeast side, and Grandville Avenue on the southwest side. And although these neighborhoods were populated by people of many different faiths, ethnicities, and social classes, they all have left a lasting imprint upon city life in Grand Rapids

This chapter contains images that show a sampling of the various aspects of neighborhood life. Grand Rapids has frequently been referred to as a "city of churches," and because they are so central to neighborhood life, many of them are included here. Pictures of schools, another neighborhood focal point that helped to define one's identity, are shown as well. Parks, where all sorts of neighborhood gatherings and recreation took place, are included to illustrate how neighborhood life really focused on all things local. The neighborhood was where everything important in life happened—it was where residents were baptized, where they played with their friends, where they worked at the local factory all day, where they went to a show with their spouse, where they bought their groceries, and often, where they were buried. All of this was contained within these microcosms of the city that defined the boundaries of life and contained almost everything that was important for the people of Grand Rapids.

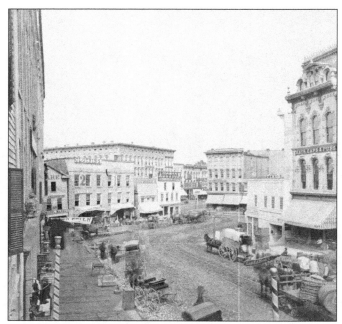

The heart of downtown Grand Rapids at Monroe Avenue and Pearl Street has had several names, including Grab Corners, Campau Square, and most recently, Rosa Parks Circle. This place, where the diagonal streets, the straight streets, and the river all come together, is indisputably the center of Grand Rapids. This early photograph shows a view looking northwest down Monroe Avenue. (Grand Rapids Public Museum.)

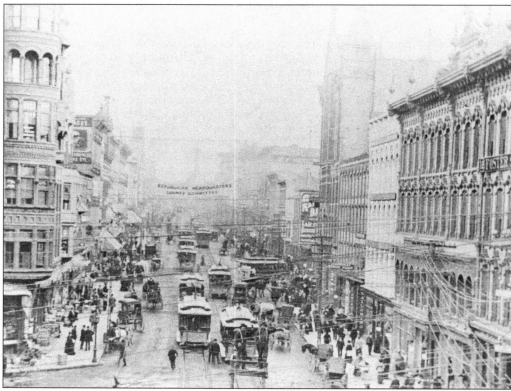

Fast-forward about 40 years, and this photograph from 1898 shows a much busier view looking up Monroe Avenue, the opposite direction from the photograph above. Note that by this time electric streetcars have replaced their horse-drawn predecessors. (Grand Rapids Public Library.)

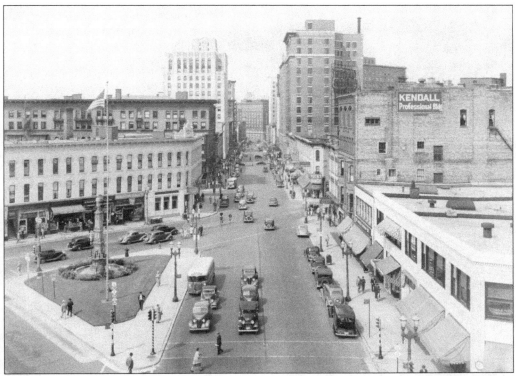

This photograph will look familiar to most Grand Rapidians. By 1937, when it was taken, the streetscape of Monroe Avenue (known as Monroe Center today) had largely assumed its present form. Some notable landmarks are the Civil War monument at lower left and the Pantlind Hotel at the end of the street. (Grand Rapids Public Museum.)

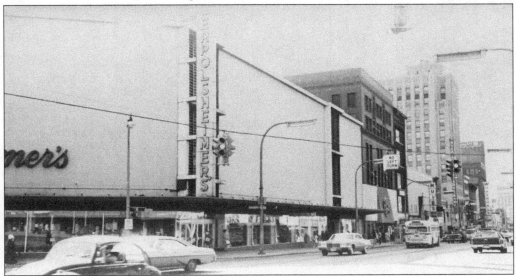

This fourth view shows a greatly diminished Monroe Avenue. By the 1970s, many downtown businesses were struggling, while others had vacated downtown for the suburbs and the new shopping centers. (Grand Rapids Public Library.)

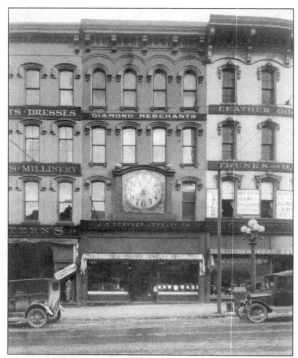

Downtown Grand Rapids is characterized by many long-term local businesses like the J.C. Herkner Jewelry Company, shown here on Monroe Avenue in downtown Grand Rapids in 1924. The company, still in business today, was founded in 1867 by Joseph Herkner shortly after he returned from serving with the 1st Michigan Engineers and Mechanics in the Civil War. (Grand Rapids Public Museum.)

This 1920s image shows Monroe Avenue, the center of downtown Grand Rapids, all decked out for the holidays. Christmas shopping at downtown department stores, riding the Herpolsheimer's Train, and watching the Santa Claus parade all brought people downtown. (Grand Rapids Public Museum.)

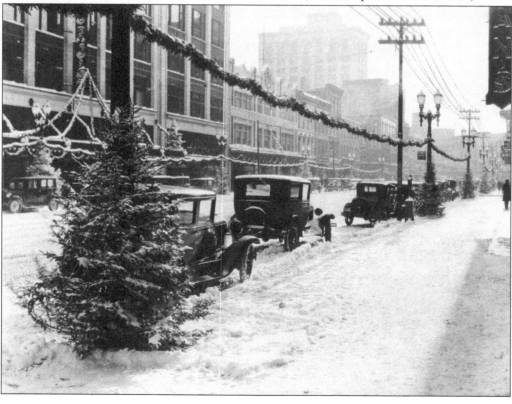

The first skyscraper in downtown Grand Rapids, the McKay Tower, is shown here being added to the top of the Grand Rapids National Bank building in 1926. (Grand Rapids Public Museum.)

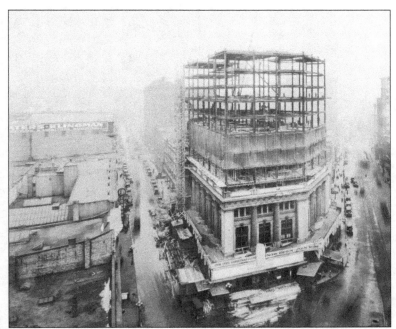

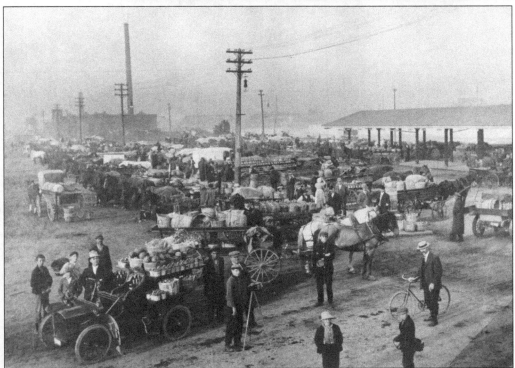

City Market was formed in 1896 when the city acquired Island No. 3 in the Grand River near Fulton Street through a bond issue of $75,000. The area was enlarged in 1897 and again in 1908 until it totaled 15.5 acres. By 1898, the city considered the market a financial success. Eventually, the market was moved because of the freeway. (Grand Rapids Public Library.)

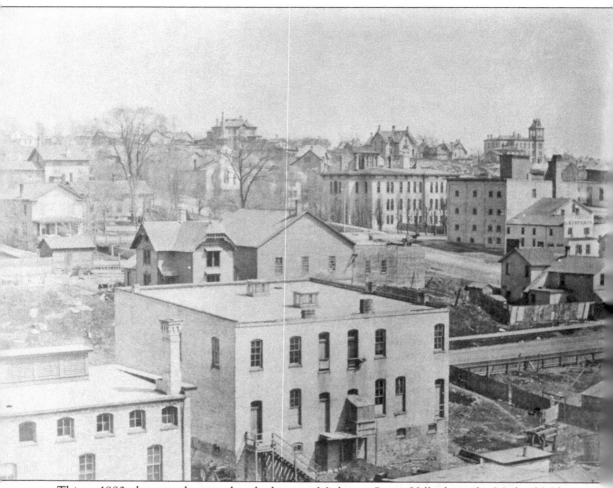

This c. 1880 photograph was taken looking up Michigan Street Hill where the Medical Mile is now located. Note C. Kusterer's City Brewery and Immanuel Lutheran Church, which is the only building in this picture still standing on the south side of Michigan Street. (Grand Rapids Public Museum.)

Many fraternal and benevolent organizations were headquartered downtown. Here, some thirsty Elks pose for a photograph in 1925. (Grand Rapids Public Museum.)

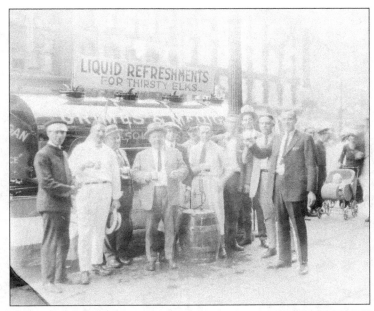

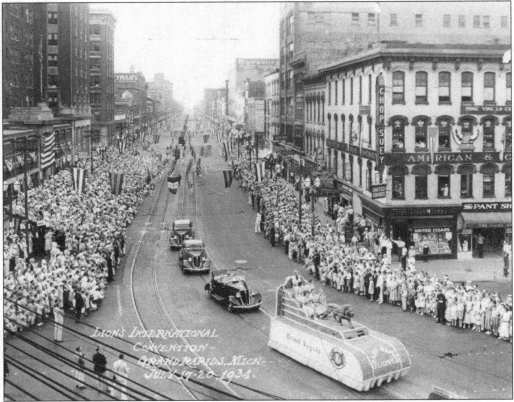

Parades, often put on by fraternal organizations, were special occasions that would bring people from surrounding areas into downtown Grand Rapids for a day of fun and spectacle. This photograph shows the Lions International Convention Parade in 1934. (Grand Rapids Public Museum.)

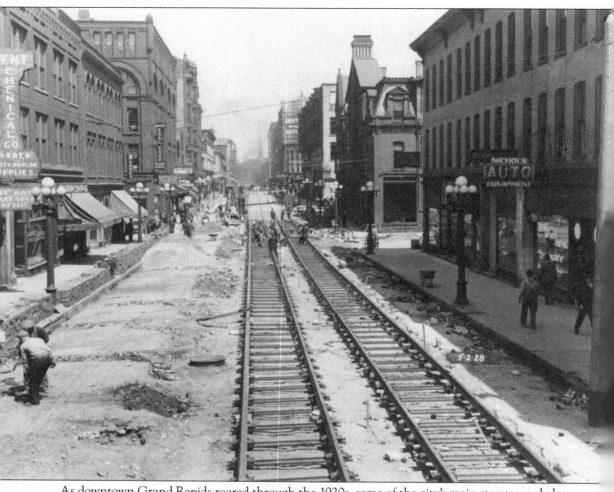

As downtown Grand Rapids roared through the 1920s, some of the city's main streets needed to be widened to accommodate streetcar, automobile, and foot traffic downtown. This image shows the widening of Division Avenue in 1928. (Grand Rapids Public Museum.)

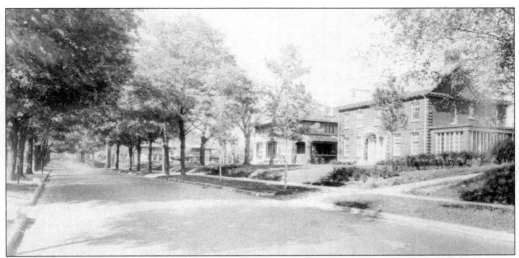

The residential neighborhood known as Heritage Hill, located south and east of downtown, is characterized by wide tree-lined streets and stately homes, like those shown here on Madison Avenue. The third house on the right is the Meyer May House, built for the department store owner in 1909 by the famous architect Frank Lloyd Wright; it is currently operated by Steelcase as a museum. (Grand Rapids Public Museum.)

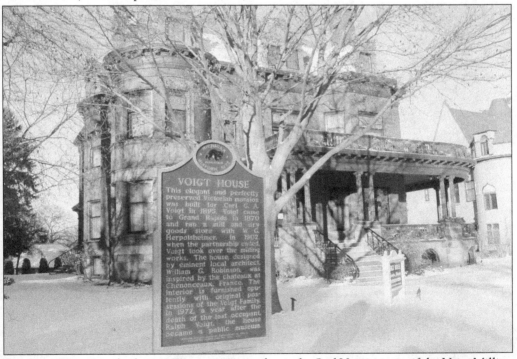

The Voigt House was built in 1895 as a retirement home for Carl Voigt, owner of the Voigt Milling Company, and his family. The Voigt family owned the house, located on College Avenue, through the 1970s, when it became a museum. The Grand Rapids Public Museum continues to preserve the Voigt House and its contents, as well as many associated Voigt business and family archives. (Grand Rapids Public Museum.)

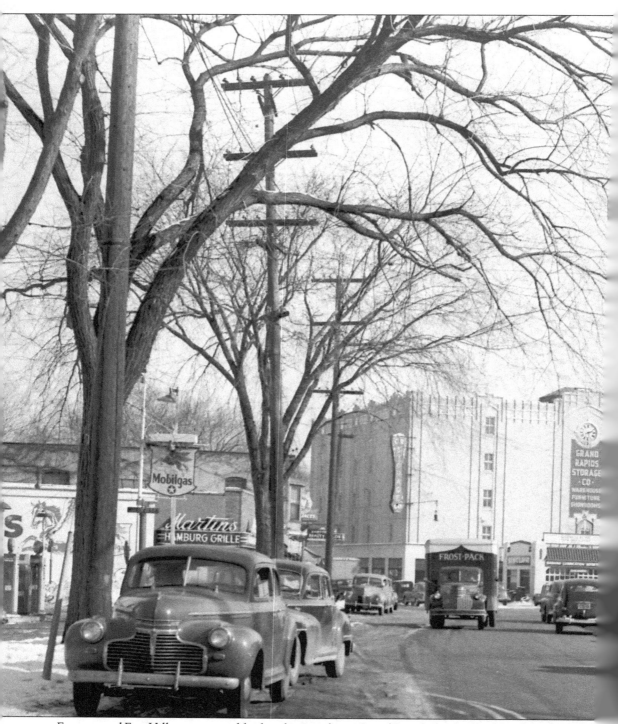

Eastown and East Hills are two neighborhoods in southeast Grand Rapids that bridge the generations and geography between the older Victorian homes in Heritage Hill and the outer suburbs. Both have a history of active small business districts mixed with residential areas. This is the intersection

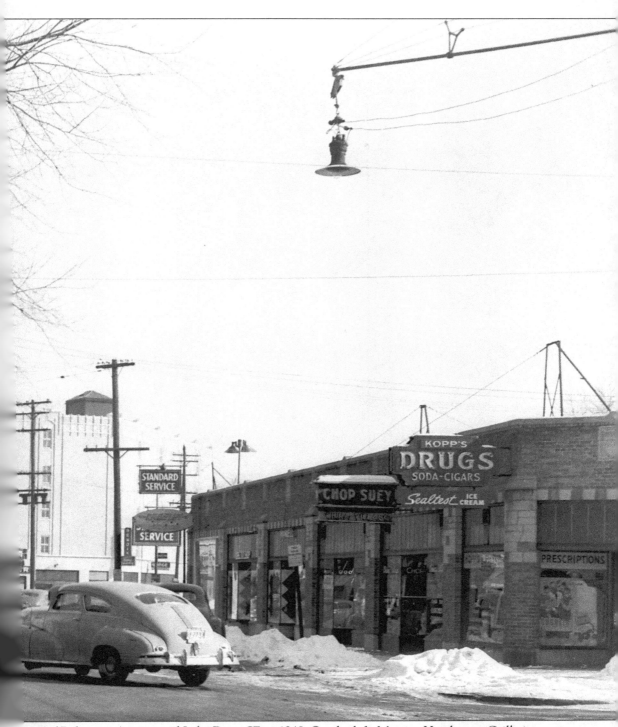

of Robinson Avenue and Lake Drive SE in 1948. On the left, Martins Hamburger Grille is now the Brandywine Diner. A Dominos has replaced the Mobilgas station. Across the street, the brick building has been replaced by the Eastown Veterinary Clinic. (Grand Rapids Public Library.)

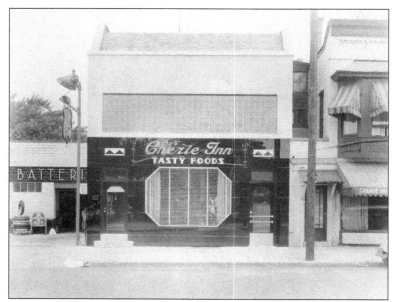

The Chérie Inn restaurant on Lake Drive is shown around 1930. This local restaurant is still in business at the same location today. (Grand Rapids Public Museum.)

Another signature building still standing in East Hills is the former Boulevard Inn, located at 951 Cherry Street near Diamond Avenue. When it was built in 1870, this building was known as the Halfway House because it was half way between downtown Grand Rapids and Reeds Lake. For many years, it was the site of dogfights, cockfights, pugilistic exhibitions, political meetings, and other unsavory activities. (Grand Rapids Public Museum.)

The Polly-Anna Pastry Shop on Wealthy Street is shown here in the Fransman Building in 1949. The building is now the location of the Jeffrey Richard Salon, one of many local businesses in this neighborhood. (Grand Rapids Public Library.)

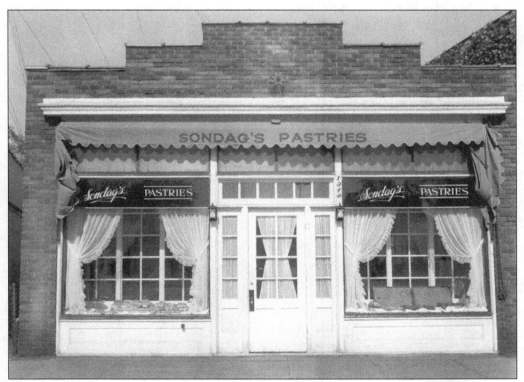

Grand Rapidians love their pastries. Several blocks away in Eastown, this photograph shows Sondag's Pastries in 1949. Today, the Redux Bookstore occupies this building on Lake Drive. (Grand Rapids Public Library.)

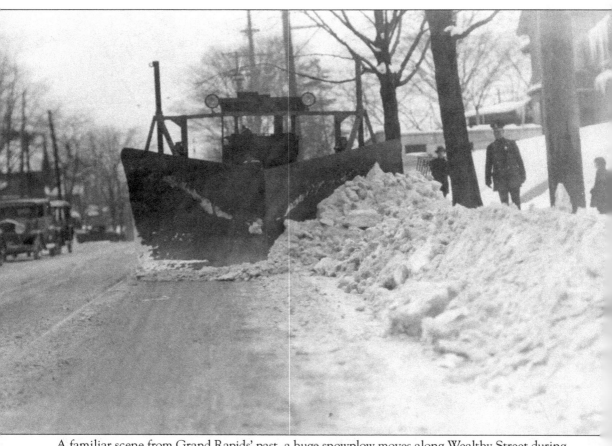

A familiar scene from Grand Rapids' past, a huge snowplow moves along Wealthy Street during the winter of 1929–1930. (Grand Rapids Public Library.)

This picture of Burton Heights Christian Reformed Church at the northeast corner of Burton Street and Jefferson Avenue was taken in 1931. The church was formed in 1905, and the congregation closed its doors in 2006. (Grand Rapids Public Library.)

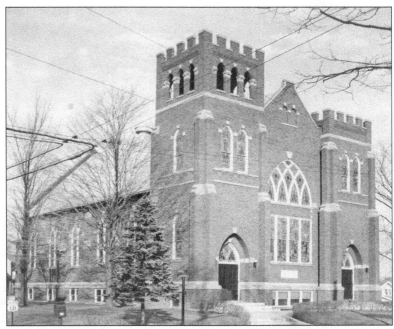

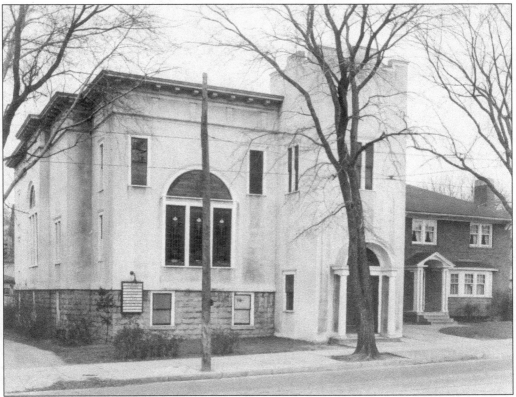

This small neighborhood church is no more. Plymouth Congregational Church, pictured here in 1931, was located at 909 Franklin Street from 1893 to 1959. (Grand Rapids Public Library.)

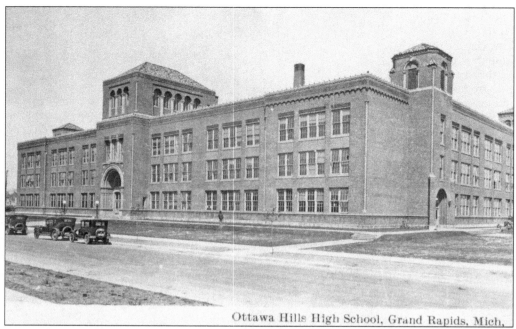

Ottawa Hills High School, Grand Rapids, Mich.

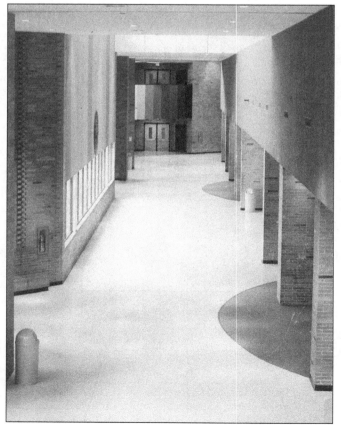

Built in 1924, the original Ottawa Hills High School, located in the southeast side neighborhood that still bears its name, was known as a suburban school at the time of its inception. Creston and Ottawa were two of the last public high schools formed in the city. (Grand Rapids Public Library.)

The new and expanded Ottawa Hills High School was opened on Burton Street in 1972. The old structure became Iroquois Middle School and was finally torn down in 2009. A new Grand Rapids Christian Elementary School continues a century of teaching and learning on the site. (Grand Rapids Public Library.)

This photograph shows the Madison Square neighborhood in 1950. Many Grand Rapids neighborhoods were characterized by a residential area centered on a small shopping and entertainment district, complete with grocery stores, movie theaters, restaurants, and retail businesses. (Grand Rapids Public Library.)

This photograph shows Seymour Square in the Alger Heights neighborhood in 1941. (Grand Rapids Public Library.)

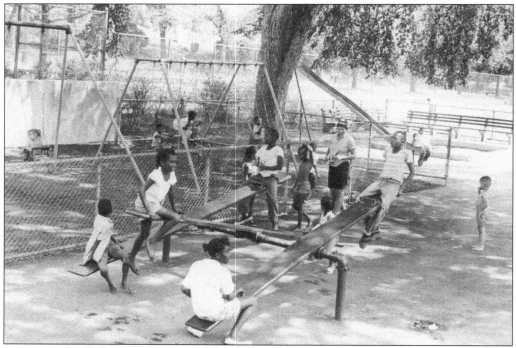

Schools and parks are important features of Grand Rapids neighborhoods. Several Grand Rapids schools, including Madison Park School shown here in the 1950s, had a dual role as both a public park and school playground. (Grand Rapids Public Library.)

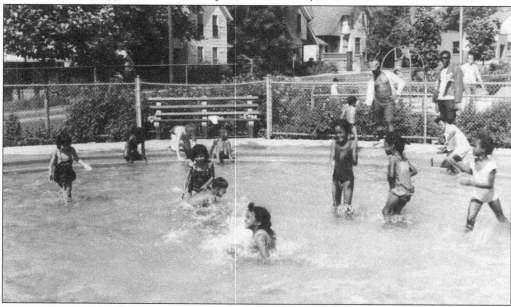

This photograph shows the Vandenberg School pool in the 1950s. For much of the 20th century, the Vandenberg School neighborhood straddled the dividing line between Heritage Hill and the predominantly African American neighborhoods to the southeast. Vandenberg School is now the Child Discovery Center Charter School. (Grand Rapids Public Library.)

One of the older neighborhood parks in the city, Cherry Park is now over 100 years old. The wading pool pictured here was a common site at many of the city parks. Now, these pools are in the process of being replaced by splash pads. (Grand Rapids Public Library.)

Pictured here is Wilcox Park in the 1950s. Originally, Wilcox Park was known as East End Park and was half the size of the current park today. When the Grand Rapids Street Railway Company went out of business, it gave its gravel pit to the city. This gravel pit was redeveloped into the southern end of Wilcox Park. (Grand Rapids Public Library.)

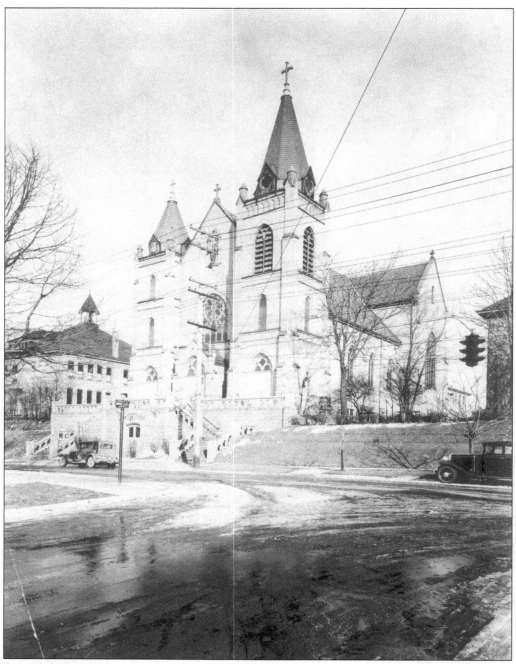

One of the more visible churches in Grand Rapids, the spires of St. Isidore's Catholic Church rise above its Diamond Avenue neighborhood and are easily seen by commuters zipping by on Interstate 196. This picture of St. Isidore's Catholic Church was taken in 1931. (Grand Rapids Public Library.)

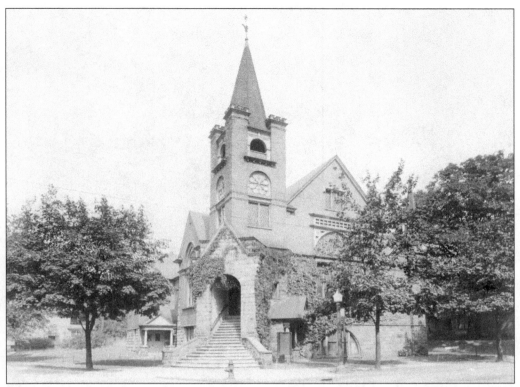

The lovely brick-and-stone arches of the Second Congregational Church were constructed in 1874 on Plainfield Avenue just north of downtown. This 1931 image captures the church when it was a central part of the Plainfield neighborhood. (Grand Rapids Public Library.)

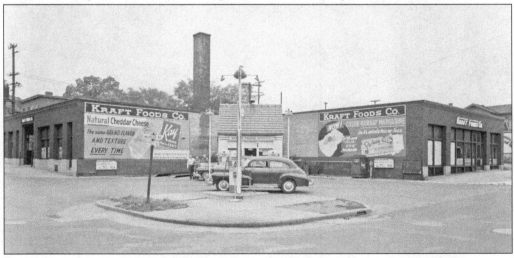

The Kraft Food Company building and the tiny Walter Finger Service Station at the corner of Michigan and Lafayette Avenues are shown here in 1950. These are some of the many small buildings along Michigan Street hill that have been demolished to make way for the Medical Mile. Note the painted signs advertising Kraft cheese and margarine on the sides of the buildings. (Grand Rapids Public Library.)

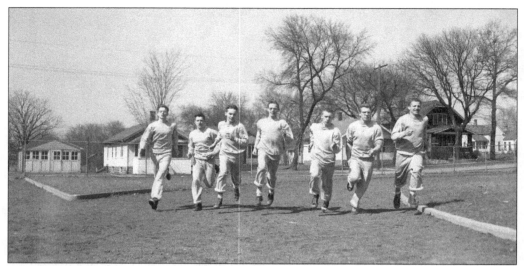

A group of high school boys runs on the Creston High School track located on Briggs Street NE. When it was originally built in 1924, Creston was considered one of the outlying suburban schools of Grand Rapids Public Schools. It is now the home of City High School. (Grand Rapids Public Library.)

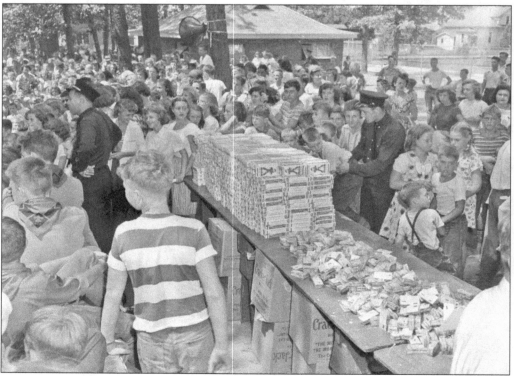

Another image from Briggs Park, this 1950s photograph shows a large neighborhood gathering, possibly for a holiday like the Fourth of July. Parks were important places where large groups of people from a neighborhood could interact and get to know one another. Note the table full of Cracker Jacks. (Grand Rapids Public Library.)

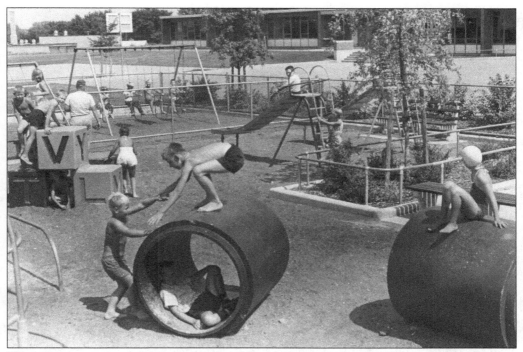

When this picture was taken in the 1950s, Hillcrest Park was a new green space for the city. Part of the highly touted school/parks plan, Hillcrest was one of many parks that doubled as a school playground as well. Today, the park is still there, but Hillcrest Elementary School is now Living Stones Christian Elementary School. (Grand Rapids Public Library.)

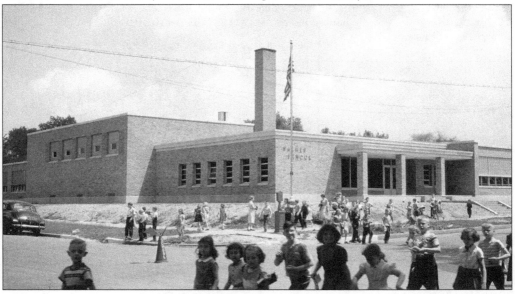

Located in the Creston neighborhood, Palmer School was, and still is, a longtime institution within the Grand Rapids Public School district. Before the building pictured here was constructed in 1954, Palmer School was housed in another building at the same site that dated from 1893. (Grand Rapids Public Library.)

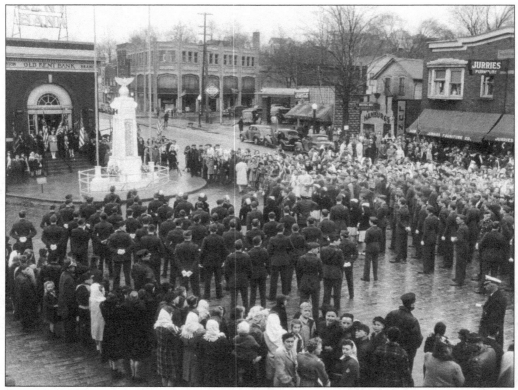

A crowd of soldiers and civilians gathers for the dedication of the World War II Memorial in front of the Old Kent Bank at the intersection of Plainfield and Coit Avenues on April 14, 1944. The memorial still stands, and the bank building is now the home of the Red Ball Jet Café. (Grand Rapids Public Museum.)

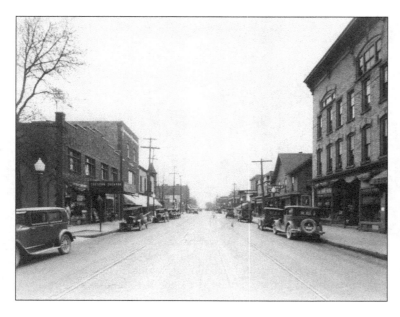

This is a c. 1930 view looking south down Plainfield Avenue in the Creston neighborhood. Like its counterparts in the other quadrants of the city, the Plainfield neighborhood boasted its own schools, shops, and entertainment venues. (Grand Rapids Public Museum.)

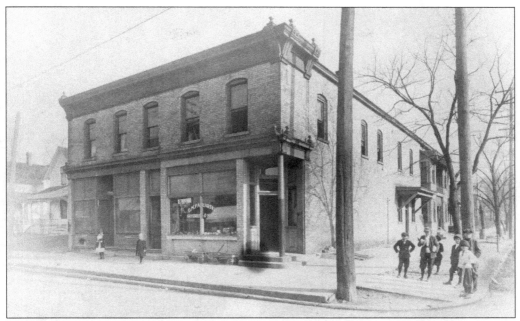

A group of children with their wagons is visible in front of the O.M. Falarski Grocery Store at the corner of Michigan and Eastern Avenues in the early 20th century. (Grand Rapids Public Museum.)

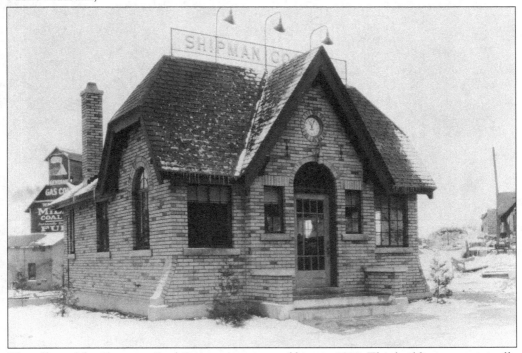

The office of the Shipman Coal Company is pictured here in 1928. This building was originally constructed in 1924 and is now the home of the popular Choo Choo Grill. (Grand Rapids Public Museum.)

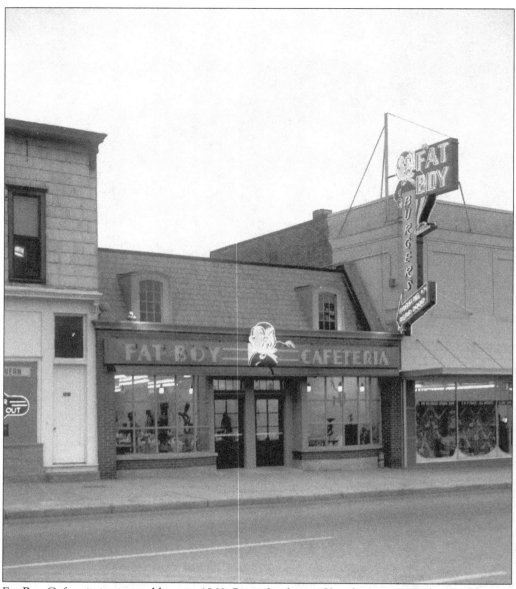

Fat Boy Cafeteria is pictured here in 1960. Part of a chain of local restaurants, this Fat Boy was located at 1960 Michigan Avenue NE. Today, the only Fat Boy restaurant remaining is on Plainfield Avenue NE. (Grand Rapids Public Library.)

Franklin Christian Reformed Church, located at 460 Franklin Street SW, is pictured here in 1931. Originally, the church was known as Holland Christian Reformed and, from 1910 to 1912, as Fifth Avenue Christian Reformed Church. The building was constructed in 1886, with an addition built in 1921. In 1966, Franklin Christian Reformed Church merged with Rogers Heights Christian Reformed Church. (Grand Rapids Public Library.)

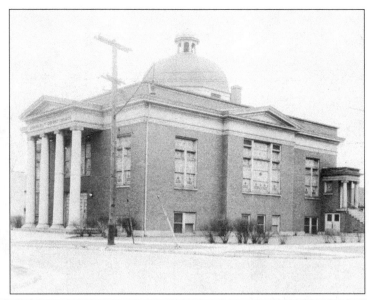

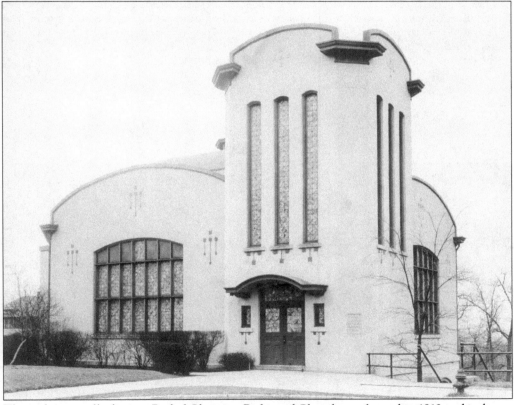

The architecturally distinct Bethel Christian Reformed Church was formed in 1912 and is shown here in 1931. The church still stands at the very end of Shamrock Street behind Cesar Chavez Elementary School on the southwest side. In 1994, Bethel merged with Grandville Avenue Christian Reformed Church to form Roosevelt Park Community Church. (Grand Rapids Public Library.)

Grandville Avenue has a fascinating history as a landing place for different ethnic groups who immigrated to Grand Rapids. The Grandville Avenue Christian School was built in 1904 and was enlarged after only 10 years to accommodate the large number of Dutch children who moved to the neighborhood during that period. (Grand Rapids Public Library.)

Football players are pictured in Rumsey Park in the 1940s. Rumsey Park was given to the city of Grand Rapids in 1915 by George Rumsey. The park had been part of Rumsey's homestead, which at one time encompassed most of the Grandville Avenue corridor. Rumsey gave it in the hopes that the park would provide a green space between the factories along Godfrey Avenue and the homes up the hill. Today, Rumsey Park is known as Clemente Park. (Grand Rapids Public Library.)

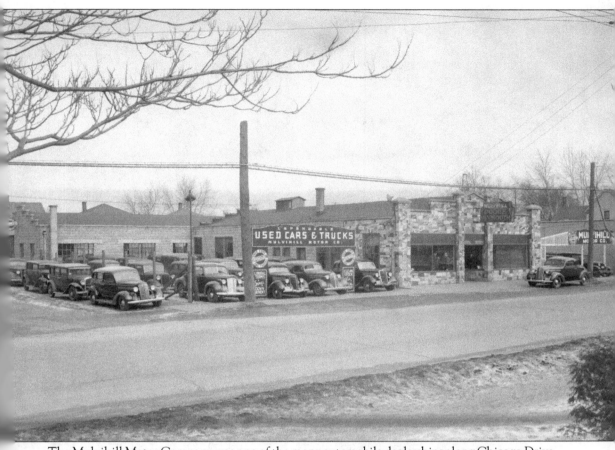

The Mulvihill Motor Company was one of the many automobile dealerships along Chicago Drive. The sign indicates that this particular used car dealership specialized in Dodges and Plymouths. (Grand Rapids Public Library.)

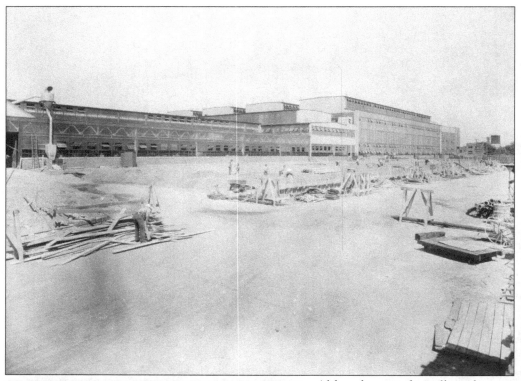

Although not technically within the Grand Rapids city limits, the General Motors Fisher Body Plant, shown here during construction in 1936, was an important feature and major employer on the city's southwest side. (Grand Rapids Public Museum.)

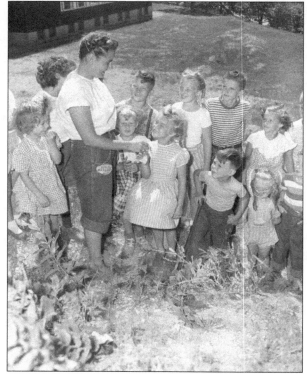

A volunteer with the Grand Rapids Recreation Department works with children during a field day at Roosevelt Park. (Grand Rapids Public Library.)

St. Mary's Catholic Church, located at 423 First Street NW, was organized in 1855 as a parish. The building shown here was built in 1874. St. Mary's was known as the parish for the large German immigrant population on Grand Rapids' west side. Prominent families, such as the Wurzburgs and Leitelts, attended St. Mary's Church. (Grand Rapids Public Library.)

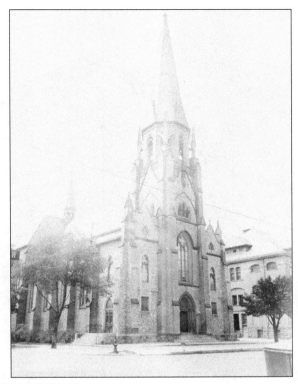

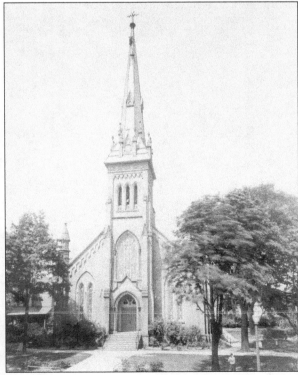

Located at 733 Bridge Street NW, St. James Catholic Church was organized as a parish in 1870. The building, seen here in 1931, was built in 1872. Originally, in the late 19th century, the church served the Irish and German immigrant groups of the Bridge Street area. (Grand Rapids Public Library.)

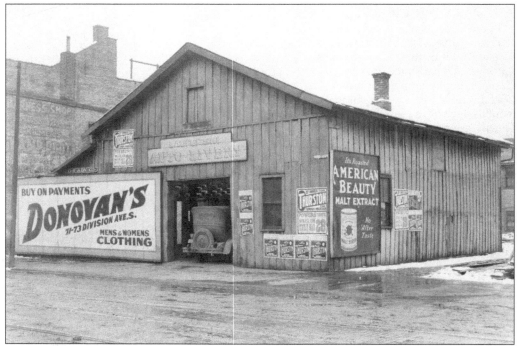

Lauferski Auto Livery was located at 423 Bridge Street NW right at the corner of West Bridge Street and Broadway Avenue. According to the photographer Murch Morris, this building was known as Eagler's Barn. It was torn down in 1928. Note the advertisements for the performance of "Thurston the Famous Magician" at the Powers Theatre downtown. (Grand Rapids Public Library.)

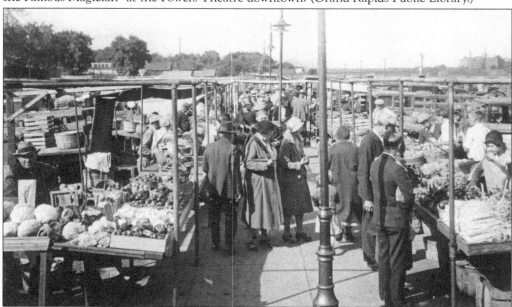

Leonard Street Market, shown here in 1930, was the most prosperous of Grand Rapids' outdoor retail markets. It was created in 1917. It continued in existence all the way until 1962, when an industrial park was built around it and spelled the market's doom. (Grand Rapids Public Library.)

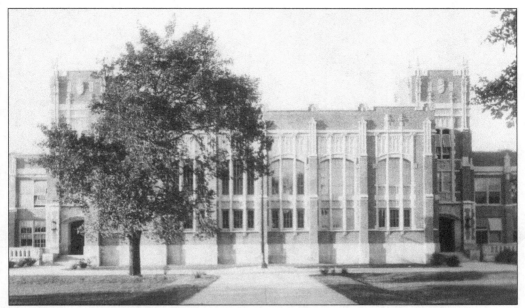

Harrison Park School, built in the lavish Collegiate Gothic style popular in the 1920s, is located at 1440 Davis Avenue NW. It is still an operating Grand Rapids Public Schools elementary school. (Grand Rapids Public Library.)

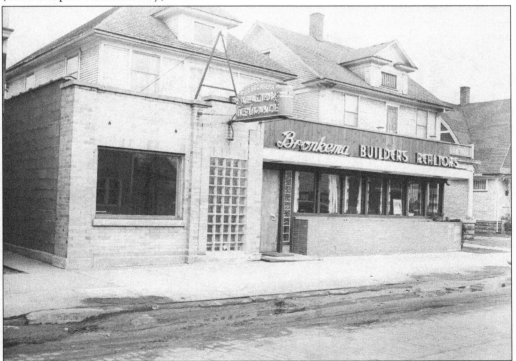

James Bronkema established his family business on Leonard Street NW and would go on to become one of the leading architects in the Mid-century Modern architectural movement. (Grand Rapids Public Library.)

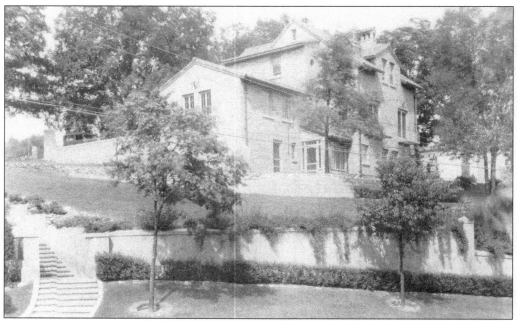

The Stone Hills estate is pictured here in 1925. Located just off of Bridge Street and Valley Avenue, this mysterious compound, accessible by tunnel, was built by businessman Frank A. Stone in 1918. The site encompassed three other homes surrounded by elaborate gardens and terraces with a beautiful view of the Grand River Valley below. (Grand Rapids Public Library.)

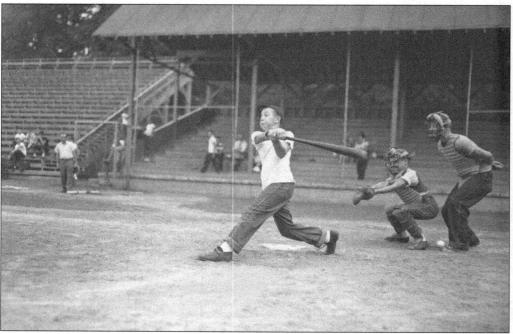

The national pastime was played in neighborhood parks and sandlots all over Grand Rapids, but few places were as nice for a ball game as Valley Field on the city's northwest side, shown here in the 1940s. (Grand Rapids Public Library.)

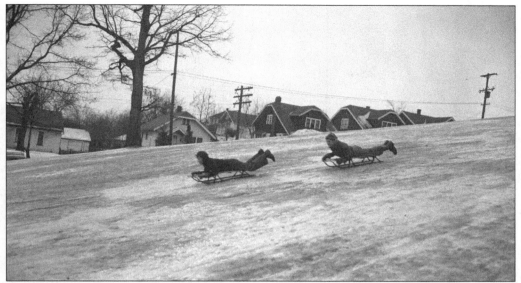

A uniquely Grand Rapids winter activity that remains enjoyable to this day is sledding down the hill at Richmond Park, originally the family farm of the Richmond family. In 1915, Rebecca Richmond, a well-known city historian and philanthropist at the time, gave the land to the city. (Grand Rapids Public Library.)

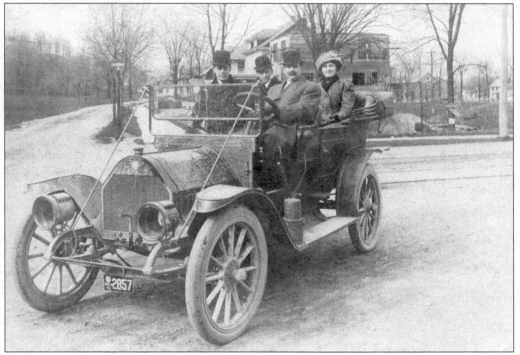

As the city grew, automobile transportation became available for more well-off residents, an increasing number of whom lived farther from where they worked. In this early photograph, Otis Felger takes a group of passengers for a spin in his Reo 30 Touring car along West Fulton Street near John Ball Park. (Grand Rapids Public Museum.)

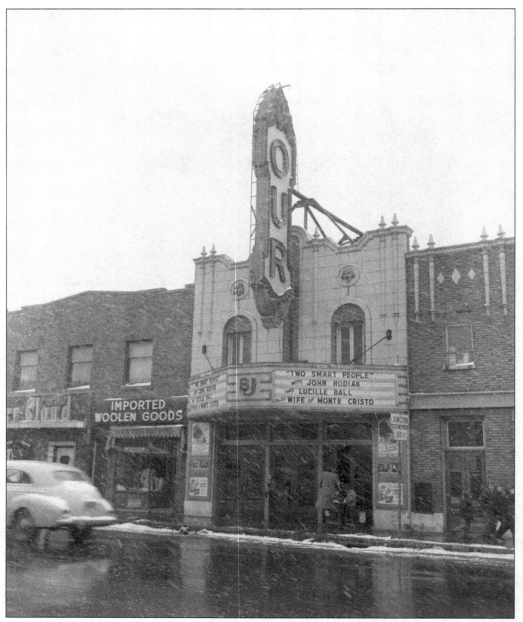

If it was too cold for sledding, one could always take in a show at Our Theatre on Leonard Street NW. In this 1946 image, the featured movie is *Two Smart People* starring Lucille Ball. This building, which in the mid-20th century was the home of the Civic Theater, does still exist, but is empty at this time. (Grand Rapids Public Library.)

Four

COMMUNITY INSTITUTIONS

The city of Grand Rapids started as a frontier trading post on the edge of the civilized world. Within a generation, the community would start to transform itself from a small village to one of the industrial powerhouses of the region and the country as a whole. With this transformation came the growth of local neighborhoods that grew up around the city for the increasing numbers of people who made Grand Rapids their home. With growth and transformation came great wealth—for some. One of the defining characteristics of Grand Rapids is, and has always been, that its wealthy citizens give back, often to create or support the important community institutions that have given the city its many artistic, commercial, and social outlets.

The community institutions presented in this chapter show a city that was coming into its own. During the 19th century, the people of Grand Rapids would start building parks, forming musical societies, enshrining war heroes, and creating tourist destinations. During the 20th century, even more institutions came into being. This came in the form of new retail outlets, the building of hospitals, and even the moving of whole communities, and the community institutions that developed in the city did all this. These institutions could be the city government or women who came together to showcase the literary tastes of the city. What each of these institutions showed is that the city had arrived. It had become a place of culture and taste. It was no longer the small frontier town of the 1840s, but rather a place that was firmly established along the banks of the Grand River.

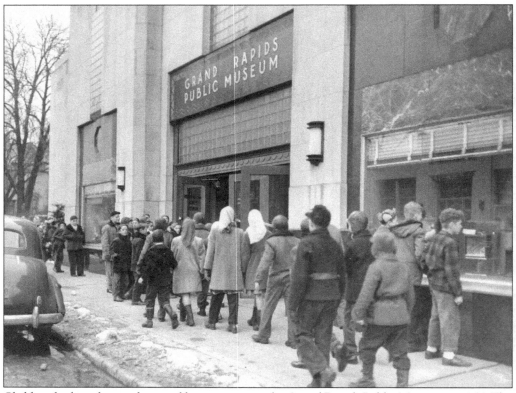

Children look in the windows and line up to enter the Grand Rapids Public Museum in 1952. The building, one of the last built with Works Progress Administration funds during the Great Depression, was designed by prominent local architect Roger Allen. (Grand Rapids Public Museum.)

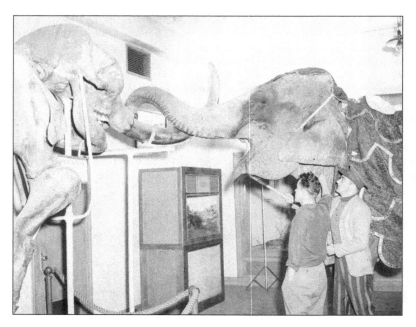

Here, a circus elephant visits a mounted mastodon skeleton, one of his distant ancestors, in an exhibit hall at the Grand Rapids Public Museum in 1951. (Grand Rapids Public Museum.)

The 70-foot fin whale skeleton has been one of the centerpieces of the museum's collection since it was collected in the early 20th century. For several decades, it hung in the main hall of the public museum on Jefferson Avenue; now, it has pride of place in the galleria at the Van Andel Museum Center. (Grand Rapids Public Museum.)

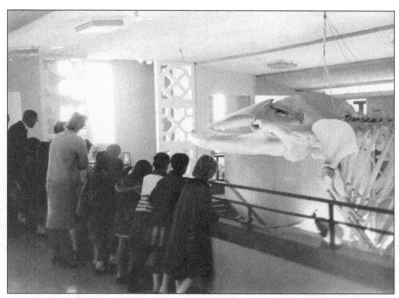

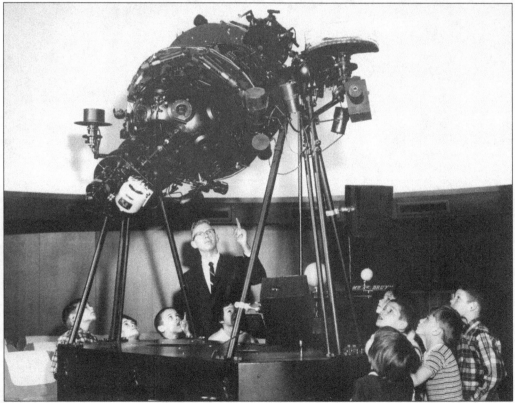

David DeBruyn, the first curator of the Grand Rapids Public Museum's planetarium, shows off the equipment to a group of amazed schoolchildren in 1966. The following year, the planetarium was renamed after fallen astronaut and Grand Rapids native Roger B. Chaffee, who died in a tragic accident while preparing for the Apollo I mission in 1967. (Grand Rapids Public Museum.)

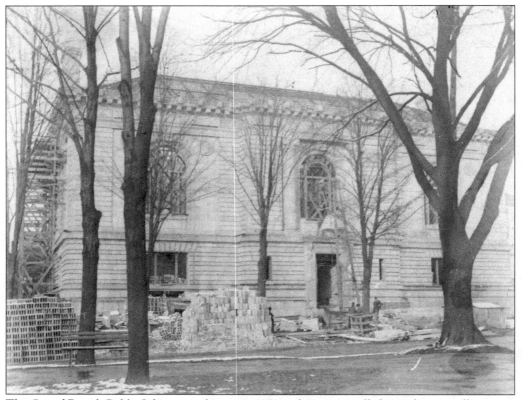

The Grand Rapids Public Library was begun in 1871 and was originally housed in a small space in the Ledyard Building. The Ryerson Building, under construction in this photograph, was started in 1902 and finished in 1904. The financing for the project was provided by native son Martin Ryerson, also the main benefactor for the Muskegon Art Museum and Chicago Art Institute. (Grand Rapids Public Library.)

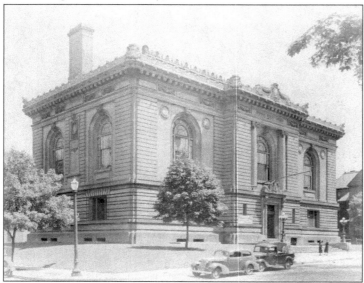

Here is the completed exterior of the Ryerson Building of the Grand Rapids Public Library. The elaborately detailed Renaissance Revival structure, typical of the period, housed the entire collection of the library until a large modern addition was constructed in the mid-1960s. (Grand Rapids Public Museum.)

The Local History Room of the Grand Rapids Public Library has been collecting documents and photographs of Grand Rapids and Michigan since 1904. The room, shown here in 1908, has grown to become one of the largest archival repositories of regional history in the state of Michigan. (Grand Rapids Public Library.)

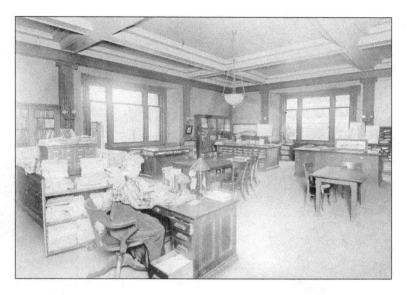

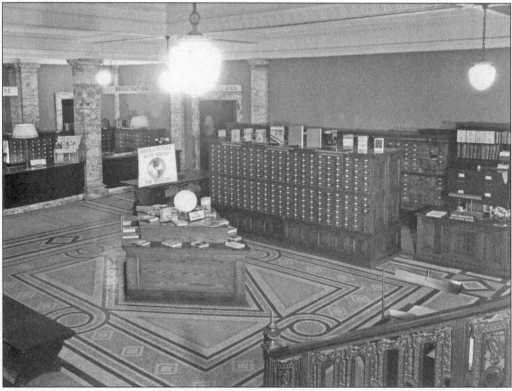

Seen here is the main lobby of the Grand Rapids Public Library sometime in the 1940s. This lobby was closed off to the general public in 1964 with the addition of the new Keeler Wing. Eventually, the lobby was reopened with the latest library renovation in 2003. (Grand Rapids Public Library.)

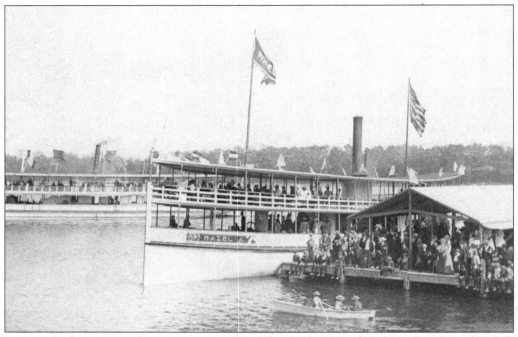

Ramona Park was a popular amusement park on the shores of Reeds Lake in East Grand Rapids from 1903 to 1954. Here, a crowd gathers on the docks to board the *Hazel A* steamboat for a trip on the lake. The *Ramona* is visible in the background. (Grand Rapids Public Museum.)

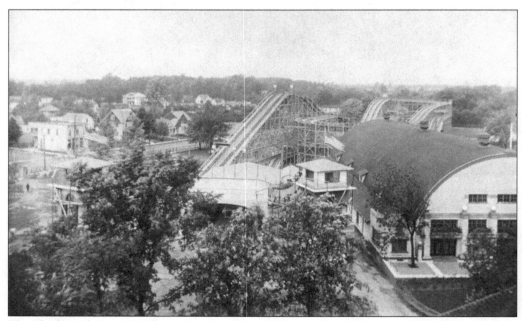

This photograph from 1914 shows the Derby Racer roller coaster, one of the most popular attractions at Ramona Park. Also visible are the Ramona pavilion on the right and the residential neighborhood of surrounding East Grand Rapids in the background. (Grand Rapids Public Museum.)

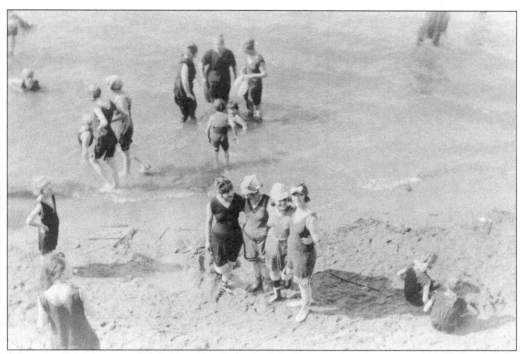

A group of bathers poses for a photograph on the beach at Reeds Lake. Note that this appears to be a gender-segregated swimming area, as no men are pictured. Also, full bathing suits and caps were worn by all the subjects. (Grand Rapids Public Museum.)

A group of dejected children looks on as the steam ship *Ramona* is put up for sale. Ramona Park closed in 1954, but it is still remembered fondly by many who visited during its long and storied tenure. (Grand Rapids Public Museum.)

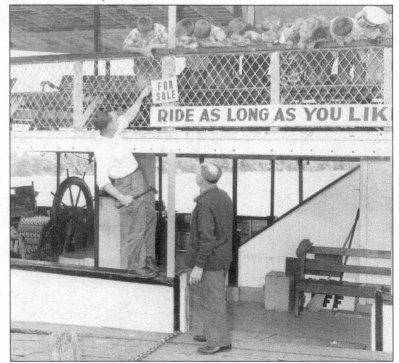

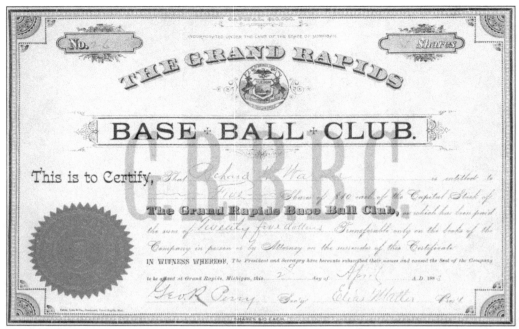

Baseball has been America's pastime since the Civil War, and Grand Rapids proved no exception. This stock certificate for the Grand Rapids Base Ball Club dates to 1883, the year the first professional team began play in Grand Rapids in the Northwestern League. (Grand Rapids Public Museum.)

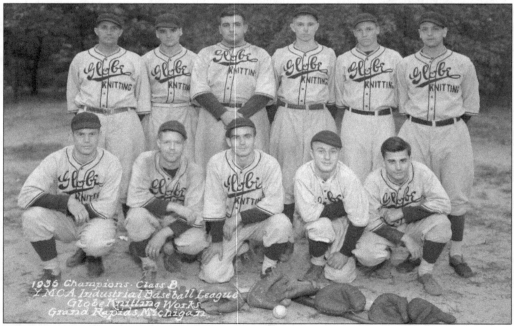

The Globe Knitting Works baseball team is pictured in 1936. In this year, team members were the Class B champions in the YMCA Industrial Baseball League of Grand Rapids. Globe Knitting Works, a clothing manufacturer, was formed in 1897. During both world wars, Globe Knitting received contracts to provide the armed forces with undergarments. (Grand Rapids Public Library.)

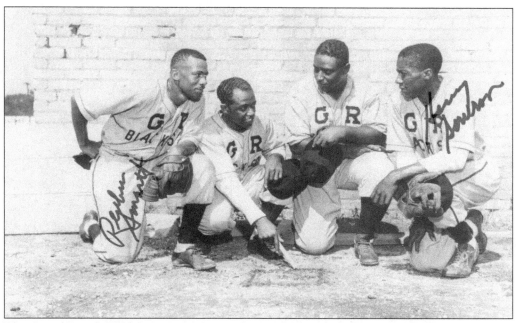

The Grand Rapids Black Sox were a semiprofessional African American baseball team in Grand Rapids in the first half of the 20th century. This 1948 image depicts, from left to right, Reuben Smartt, Ted Rasberry, Olan "Jelly" Taylor, and Henry Saverson. (Grand Rapids Public Museum.)

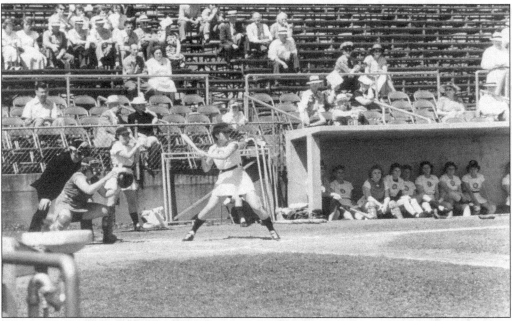

During World War II, Philip Wrigley created the All-American Girls Professional Baseball League (AAGPBL). From 1945 to 1954, the Grand Rapids Chicks entertained their fans at home games at South High Field in Grand Rapids and Bigelow Field in Wyoming. The Chicks won the AAGPBL championship in 1947 and 1953, but a year later, the AAGPBL went out of business. Pictured here is Doris Satterfield at bat. (Grand Rapids Public Museum.)

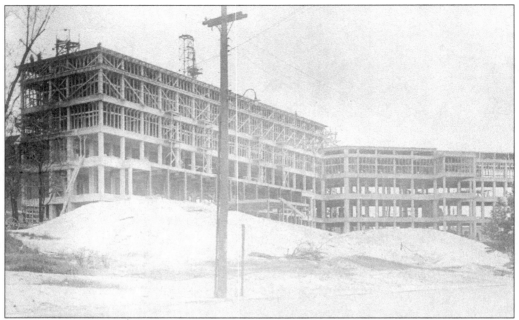

This 1924 photograph shows the construction of Butterworth Hospital. The hospital, today known as Spectrum Health, started in 1872 as part of St. Mark's Episcopal Church. Originally, it was located in a house at Bond Street and Crescent Avenue. (Grand Rapids Public Library.)

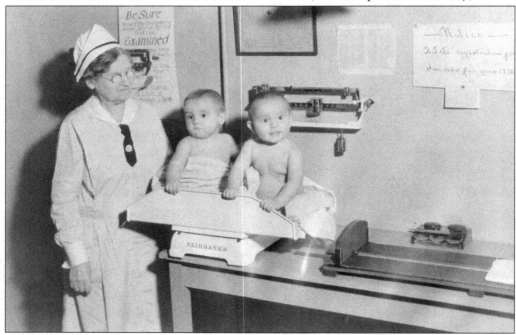

One of the many charitable enterprises sponsored by the D.A. Blodgett Home for Children was the Clinic for Infant Feeding. The mission of this medical outreach facility was to create strong and healthy mothers and babies through the distribution of healthy breast milk. (Grand Rapids Public Museum.)

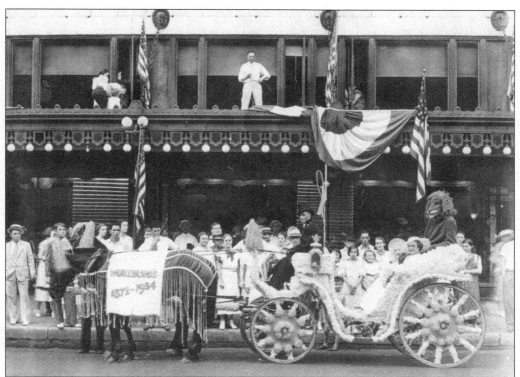

Beyond their role as shopping destinations, the large Grand Rapids department stores, like Wurzburg's, actively participated in community-building activities; for example, many sponsored annual parades. Shown here is an anniversary parade in 1934. (Grand Rapids Public Museum.)

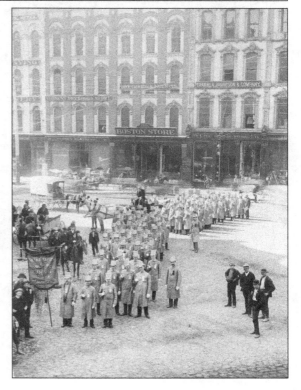

This 1890s picture shows the members of the Grand Rapids Typographical Union, all decked out for a convention or parade. This labor union was one of the earliest in the city, having originally formed in the Withey Block of what is now lower Monroe Avenue. Labor unions like this were important facets of the fabric of community life in Grand Rapids. (Grand Rapids Public Library.)

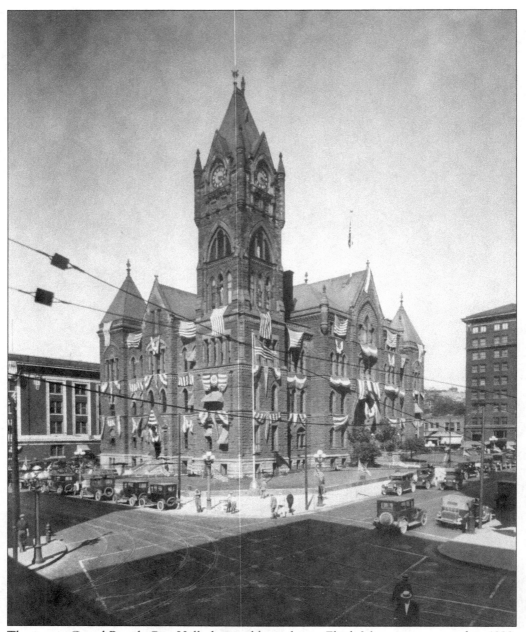

The iconic Grand Rapids City Hall, designed by architect Elijah Meyers, was opened in 1888. City hall was an important centerpiece of the downtown landscape for many years. The building is shown here around 1930, decorated for Independence Day celebrations. (Grand Rapids Public Museum.)

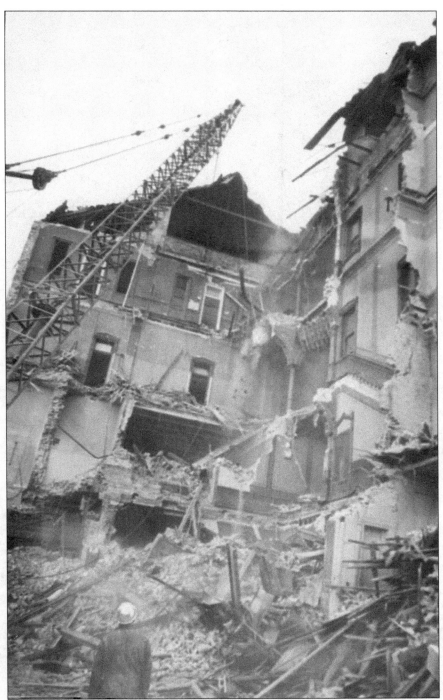

In 1969, city hall was demolished as part of a program of urban renewal that transformed the face of downtown Grand Rapids. The effects of this pivotal decision in Grand Rapids history are still actively felt and debated, even 50 years later. Portions of city hall, including the clock, were saved and are now in the collections of the Grand Rapids Public Museum. (Grand Rapids Public Museum.)

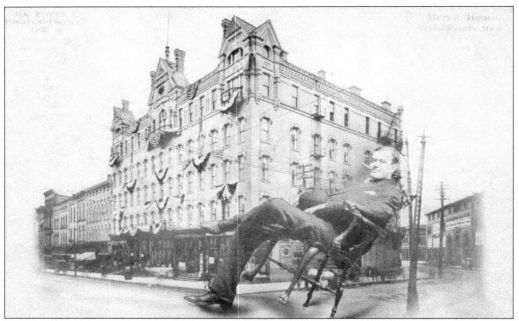

This postcard, from the famous Mr. Rover series, shows the exterior of the Morton House Hotel on the corner of Ionia and Monroe Avenues in downtown Grand Rapids. Large and fancy hotels like the Morton hosted the many out-of-town guests who visited Grand Rapids, especially during the semiannual furniture markets. (Grand Rapids Public Museum.)

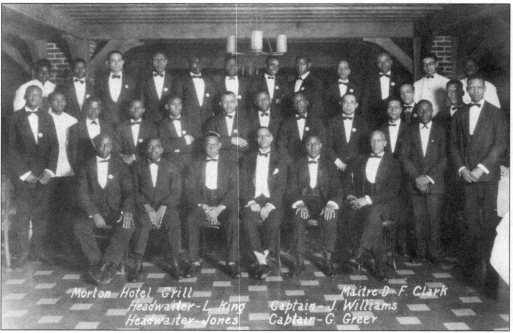

In addition to the prestige they added to the town, hotels like the Morton were major employers, especially for African Americans, who often worked as waiters in the hotel restaurants. (Grand Rapids Public Museum.)

The Rowe Hotel, located on the northwest corner of Michigan and Monroe Avenues, was another fancy downtown establishment, completed in 1923. This photograph shows the half-built hotel, with a large sign for the builders, the longtime Grand Rapids firm Owens-Ames-Kimball Co. (Grand Rapids Public Museum.)

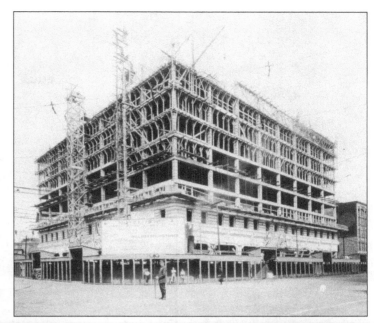

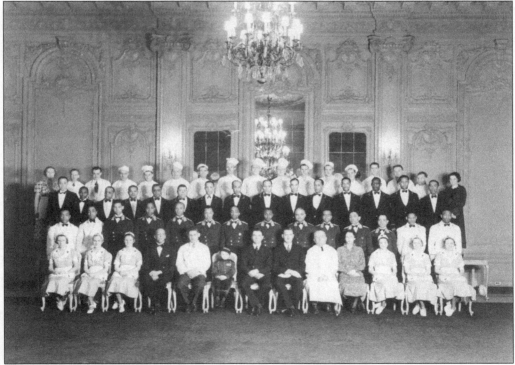

Pictured around 1940 is the Rowe Hotel's hospitality staff. Sitting near the center of the first row is Tony Borris, the Grand Rapidian better known as "Philip Morris Johnny." In 1938, Borris became a popular advertising character for the tobacco giant and traveled the country dressed in his signature bell captain's uniform, shouting his famous "call for Philip Mo-or-or-iss" slogan. (Grand Rapids Public Museum.)

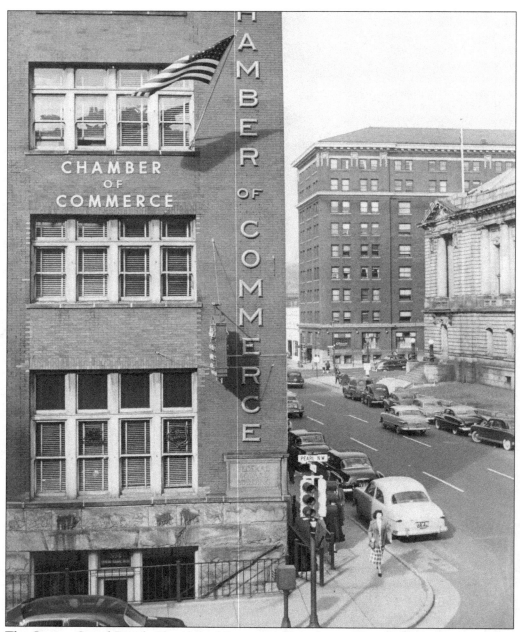

The Greater Grand Rapids Chamber of Commerce started in 1871 as the Grand Rapids Board of Trade and then the Association of Commerce, filling the role as the primary advocate of the business community in the city and the West Michigan region. This 1940s photograph shows the chamber offices in the Federal Square Building. (Grand Rapids Public Library.)

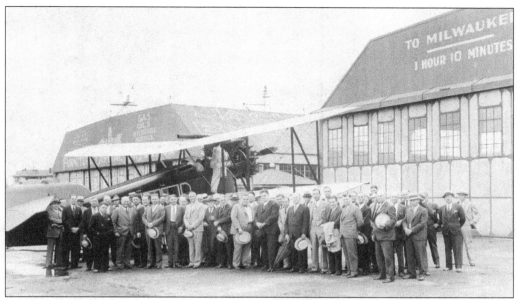

A crowd gathers in front of an airplane at the Kohler Aviation Headquarters at the Grand Rapids Airport in 1931. Kohler Aviation was an early airline that regularly flew passengers and freight between Grand Rapids and Milwaukee. (Grand Rapids Public Museum.)

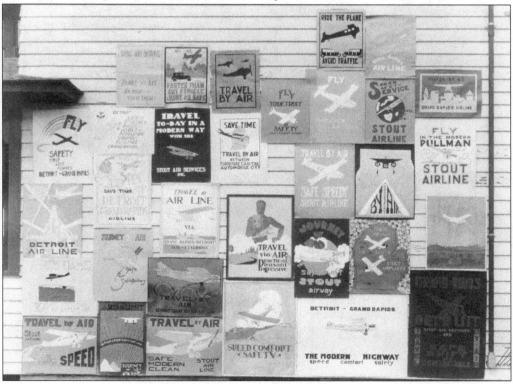

The Stout Airline used a variety of posters to advertise its air service between Grand Rapids and Detroit. (Grand Rapids Public Museum.)

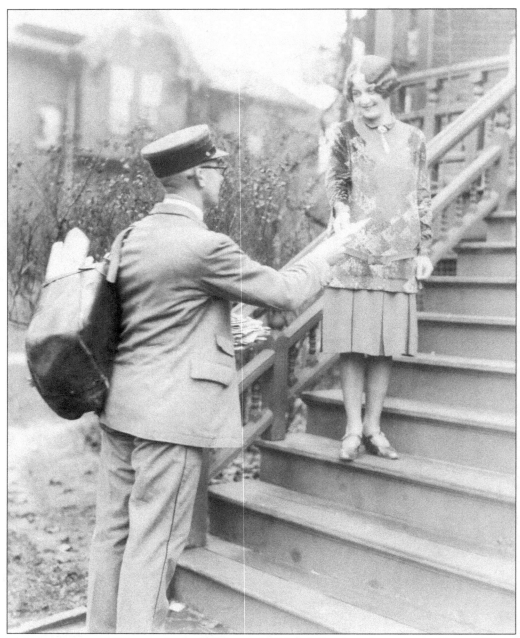

This charming c. 1930 image depicts a US postal worker delivering a letter to a resident of Grand Rapids. (Grand Rapids Public Museum.)

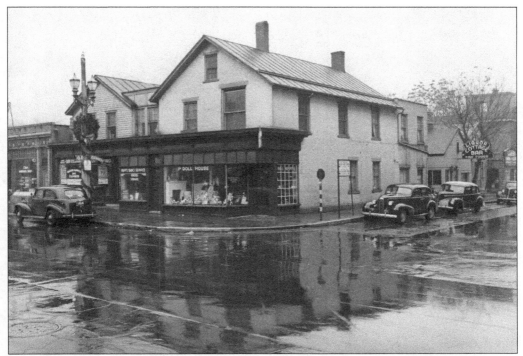

This 1940 photograph is of the Blake Store, located at Fulton Street and LaGrave Avenue. Right behind the Blake Store is the Cottage Bar, which is still in operation today. At this time, the Cottage Bar would have been 13 years old, having been established originally in 1927. (Grand Rapids Public Library.)

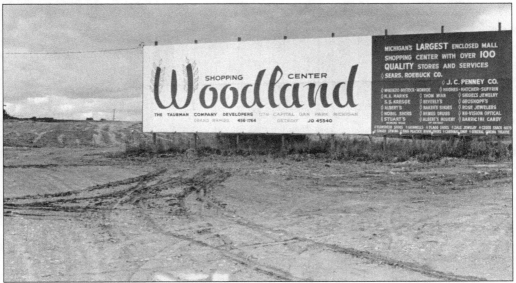

This photograph, part of the chamber of commerce archival collection of the library, shows the ground breaking of Woodland Mall on 28th Street. Some of the original stores highlighted on the sign include Siegel's Jewelry, Barrcini Candy, and Albert's Hosiery of Detroit, among many others. (Grand Rapids Public Library.)

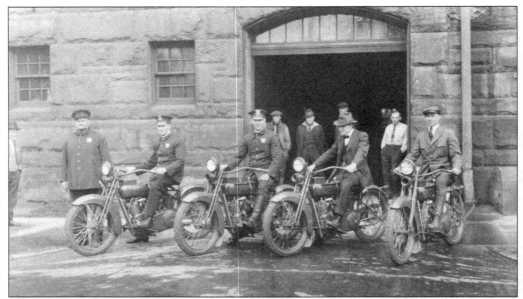

Members of the Grand Rapids Police Department pose on their new Harley Davidson motorcycles around 1917. (Grand Rapids Public Museum.)

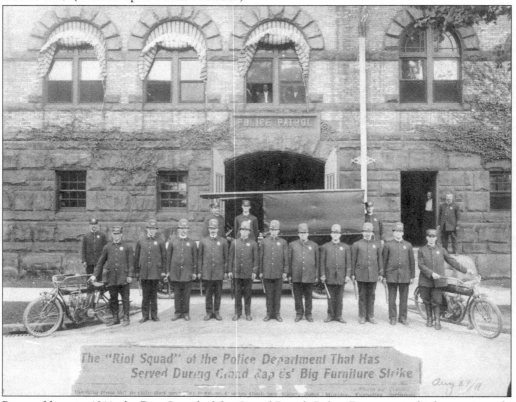

Pictured here in 1911, the Riot Squad of the Grand Rapids Police Department had an active role during the famous Furniture Strike of 1911. (Grand Rapids Public Library.)

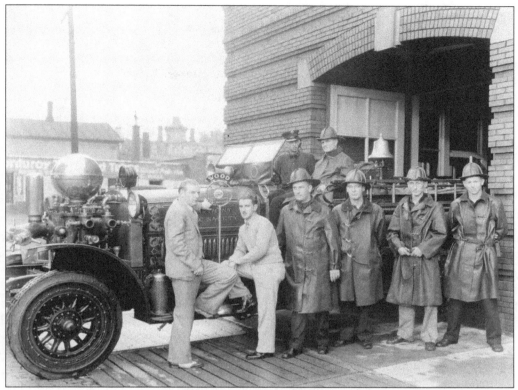

Reporters from WOOD Radio and a group of Grand Rapids Fire Department firefighters pose with their new Ahrens Fox fire engine at the LaGrave Avenue Fire Station in 1931. (Grand Rapids Public Museum.)

The Grand Rapids Fire Department is seen responding to a call at the Marquette Lumber Company on Fulton Street around 1910. (Grand Rapids Public Museum.)

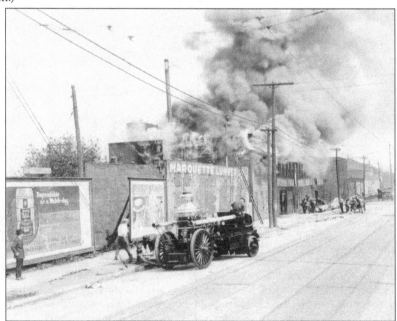

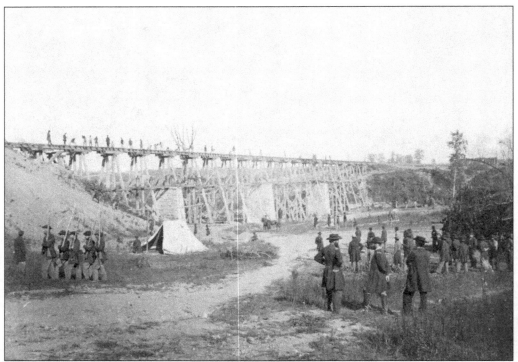

This photograph shows the 1st Michigan Engineers and Mechanics building a bridge over the Elk River during the Civil War. Included in the picture are Dr. William H. DeCamp, Charles W. Calkins, Capt. James Sligh, Capt. John McCrath, and Lieutenant Broadwell. (Grand Rapids Public Museum.)

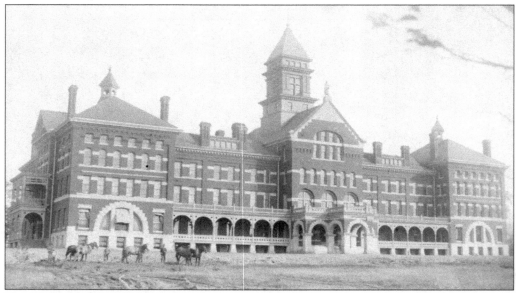

The Michigan Soldier's Home is pictured around the time of its completion in 1886. This was one of the most photographed buildings in early Grand Rapids and was a home for disabled veterans of the Civil War and many other later conflicts. (Grand Rapids Public Museum.)

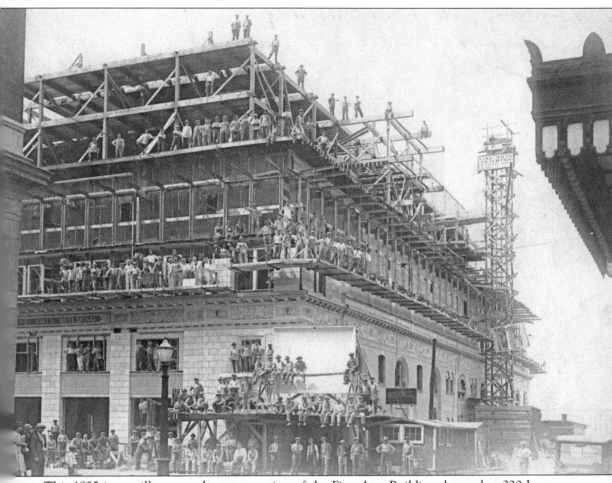

This 1925 image illustrates the construction of the Fine Arts Building, located at 220 Lyon Street NW. According to the notes of photographer Murch Morris, there were upwards of 100 construction workers on the building during the taking of this photograph. Now part of the Amway Grand Plaza Hotel, the building features elaborate terra-cotta panels depicting the arts of furniture manufacture. (Grand Rapids Public Library.)

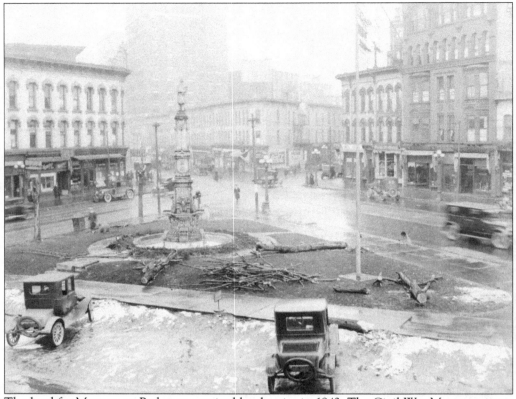

The land for Monument Park was acquired by the city in 1843. The Civil War Monument was erected in 1885 and was the first in the country to include a built-in fountain and the first to commemorate the role that women played in the Civil War. The monument and fountain were renovated and repaired in 1959 and underwent a major restoration in 2003. (Grand Rapids Public Museum.)

Veteran's Park is the oldest of the parks in Grand Rapids. Pictured here in 1872, Veteran's Park was known as Fulton Street Park at the time. On the right is Park Congregational Church, which is still there today. (Grand Rapids Public Library.)

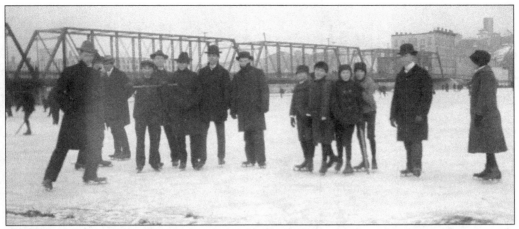

When the weather permitted, ice-skating on the Grand River was an entertaining, if not entirely safe, diversion from the drudgery of winter. (Grand Rapids Public Museum.)

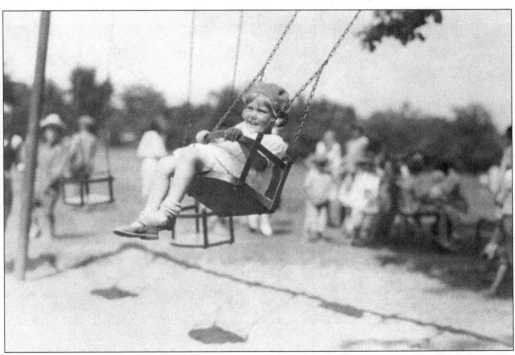

An unidentified girl enjoys a ride on a swing at a Grand Rapids park. Presumably, a family picnic or other event is taking place in the background. (Grand Rapids Public Museum.)

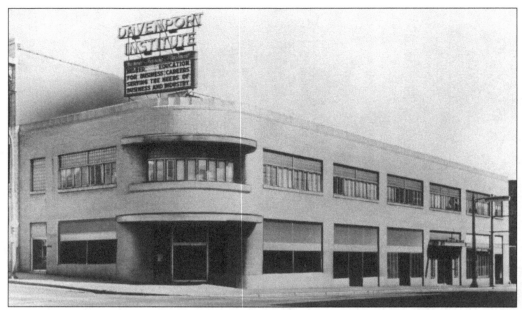

Shown here at the corner of Fulton Street and Division Avenue is the Davenport Institute, now known as Davenport College. Prof. C.G. Swensberg started Davenport in 1866. Originally known as the Grand Rapids Business College, it was the only business college in the city until 1892, when the Mclachlan Business University was begun. In 1924, both institutions combined into the Davenport-Mclachlan Institute. Eventually, this became the Davenport College of Business. (Grand Rapids Public Library.)

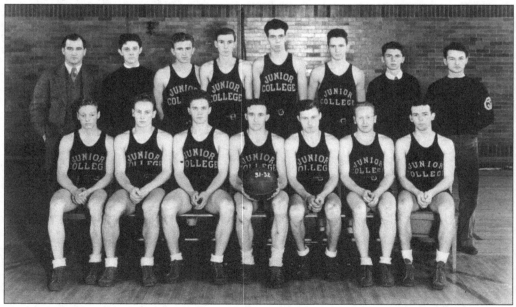

Founded in 1914, the Grand Rapids Junior (later, Community) College has provided over 100 years of service to those seeking to better themselves through education in Grand Rapids. Its downtown campus is an anchor for the community. Shown here is the school's c. 1920 basketball team. (Grand Rapids Public Museum.)

A Michigan Bell telephone operator demonstrates how to use the company's directories to connect phone calls anywhere in the city. (Grand Rapids Public Museum.)

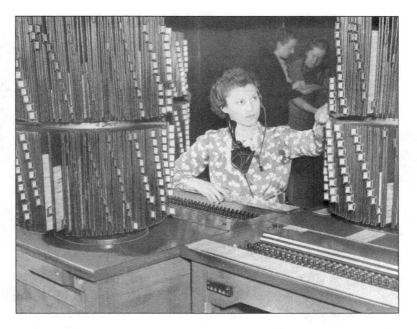

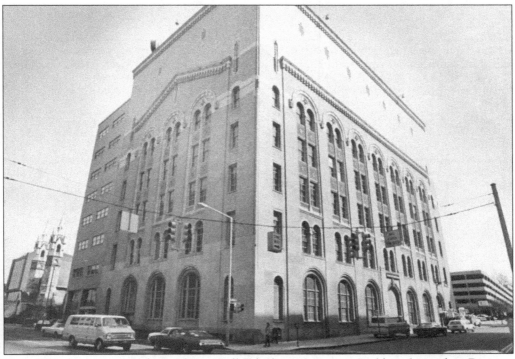

Pictured is the exterior of the Michigan Bell Telephone Company Building, located on Division Avenue at the foot of Fountain Street. Architect Wirt Rowland designed this building; it had a much more graceful Gothic Revival facade until the expansion of the phone company necessitated several additions to the building. (Grand Rapids Public Museum.)

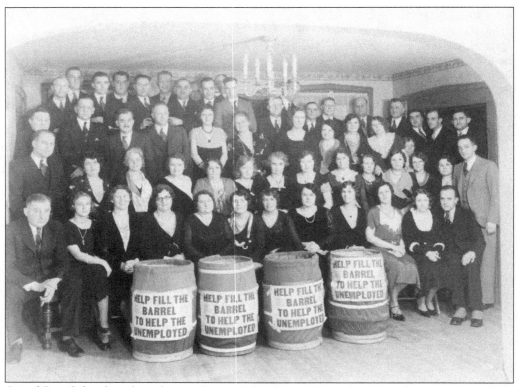

Grand Rapids has long been known for its philanthropy. Here, charity workers encourage their fellow Grand Rapidians to "Help Fill the Barrel" to feed the unemployed during the Great Depression. (Grand Rapids Public Museum.)

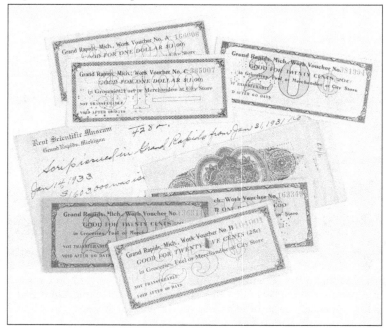

During the Depression, the City of Grand Rapids employed many out-of-work people to complete civic improvement projects. Because currency was unavailable, they were paid with city-issued scrip, which could be exchanged at city stores for food or other necessities. (Grand Rapids Public Museum.)

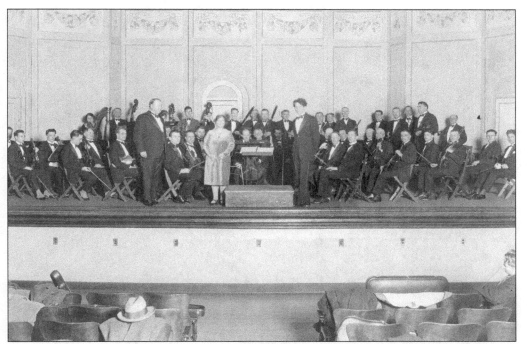

The Grand Rapids Symphony is shown here in the Majestic Theater on Division Avenue about 1925. Conductor Karl Wecker is standing on the right. The symphony had started just four years before in 1921. (Grand Rapids Public Library.)

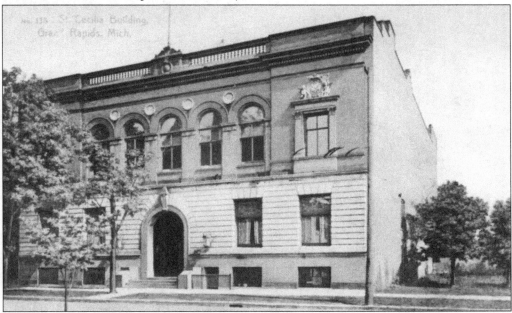

The St. Cecilia Society was formed in 1883. Its building, shown here, was financed by the women of the society and construction was finished in 1886. Since that time, the St. Cecilia Society has promoted and showcased the musical arts for generations of Grand Rapidians. (Grand Rapids Public Library.)

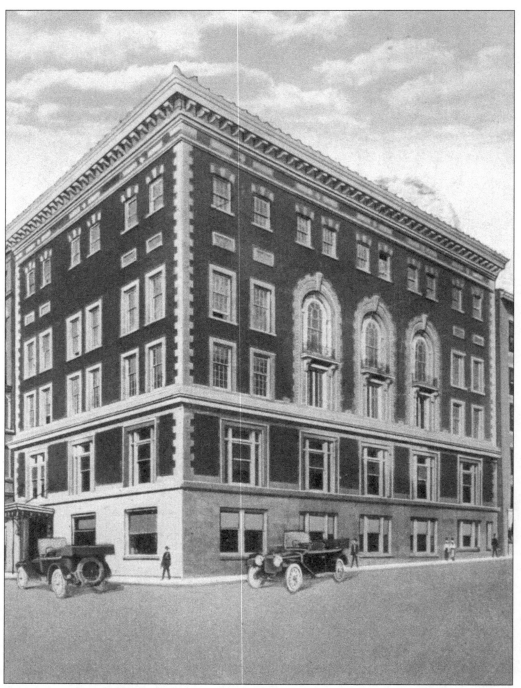

Founded in 1881, the Peninsular Club was once the most prestigious organization in the city. Located at Ottawa Avenue and Fountain Street, the Peninsular Club was the focal point for the city's elite. Many of Grand Rapids' leading lights were members of the club, including John Lawrence, Arthur Vandenberg, Julius Houseman, Gerald Ford, E.F. Uhl, and many others. (Grand Rapids Public Library.)

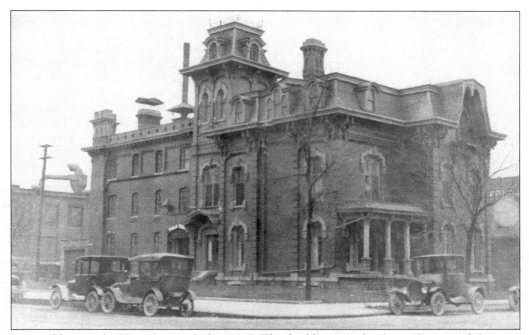

Pictured here is the Kent County Jail in 1927. This building stood at Louis Street and Campau Avenue from 1872 to 1958. It certainly looks very different than the modern Kent County Jail on Ball Street NE. (Grand Rapids Public Library.)

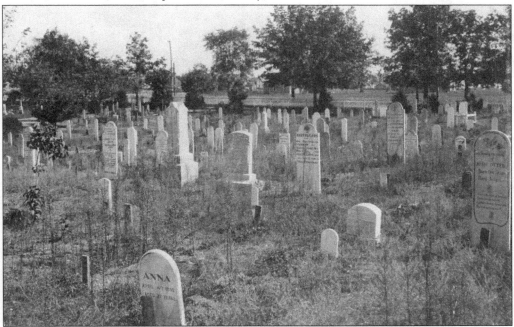

Oak Hill Cemetery was established as a city cemetery in 1859. North of Hall Street, the land was known as Oak Hill Cemetery and was a private cemetery run by the Oak Hill Cemetery Association. South of Hall Street, the land was owned by the City of Grand Rapids. The two eventually were combined to form the present-day cemetery. (Grand Rapids Public Library.)

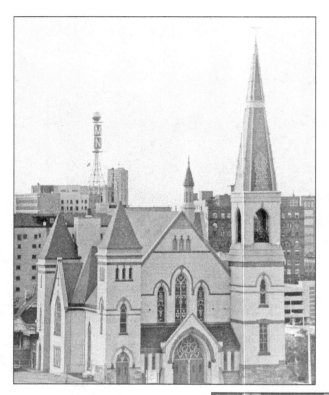

For much of the latter half of the 20th century, the Weatherball has been a familiar sight in Grand Rapids. Originally seated on top of the Michigan National Bank Building in downtown Grand Rapids, this landmark relayed weather forecasts for many people in the downtown area. The Weatherball was taken down in 1987. In 1999, television station WZZM purchased the Weatherball and installed it at its location at Alpine Avenue and Three Mile Road. (Grand Rapids Public Library.)

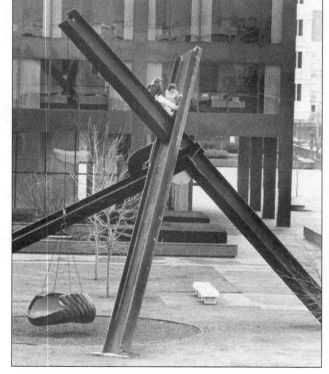

Installed in 1977 as part of the event Sculpture off the Pedestal, *Motu Viget*, better known as simply "the Tire Swing," is a kinetic art sculpture by Mark di Suvero. (Grand Rapids Press Collection at the Grand Rapids Public Museum.)

William Alden Smith (left) came to Grand Rapids when he was 12 years old. He supported his family by selling popcorn on the city streets. Despite these humble beginnings, he eventually became a US senator. Smith is perhaps best known for chairing the Senate's official inquiry into the sinking of the *Titanic* in 1912. Another US senator from Grand Rapids, Arthur Vandenberg (right) is pictured on the cover of an early edition of *On the Town* magazine. Born in Grand Rapids in 1884, Vandenberg represented the state of Michigan as a US senator from 1928 to 1951. He is likely best known for the Vandenberg resolution, a 1948 agreement key to signing the North Atlantic Treaty, which established NATO. (Both, Grand Rapids Public Museum.)

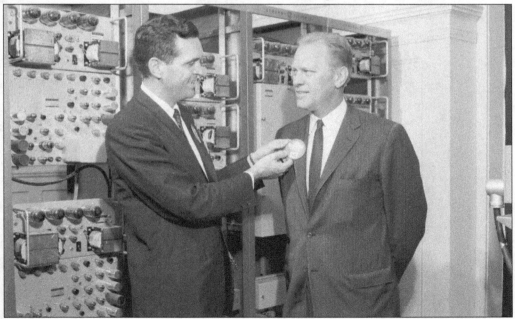

Congressman Gerald R. Ford (right) is seen with general manager Mar Wodlinger at the WZZM television station in Grand Rapids, Michigan. This photograph was taken on October 19, 1962, about two weeks before the station went on the air for the first time. (Grand Rapids Public Library.)

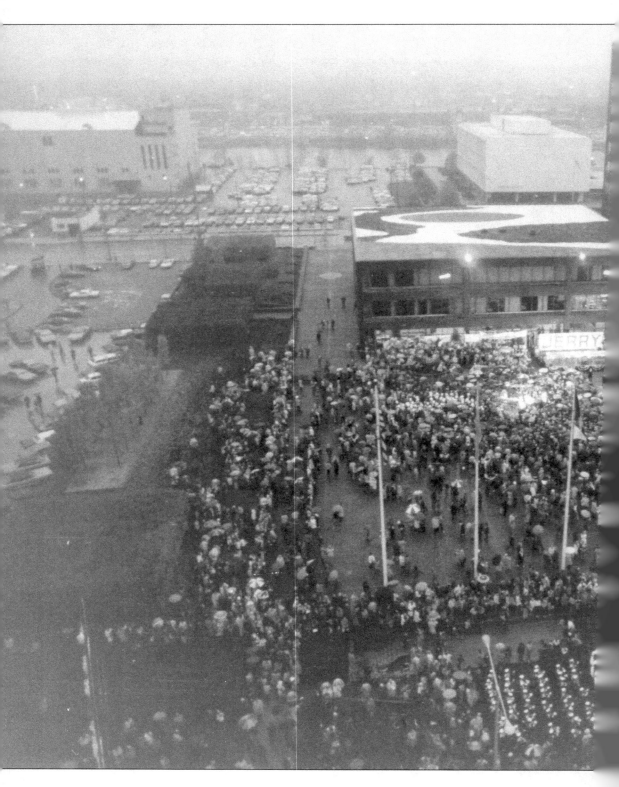

Calder Plaza, built after the urban renewal period, was intended as the town square for the city. The sculpture *La Grande Vitesse*, installed in 1969, was the first installation of public art in the city. The event taking place in this photograph was the 1970 Gerald Ford Day, which was held in Calder Plaza that year. (Grand Rapids Public Library.)

Visit us at
arcadiapublishing.com

CPSIA information can be obtained
at www.ICGtesting.com
Printed in the USA
BVHW051152100619
550591BV00014BA/894/P